# KARSH: BEYOND THE CAMERA

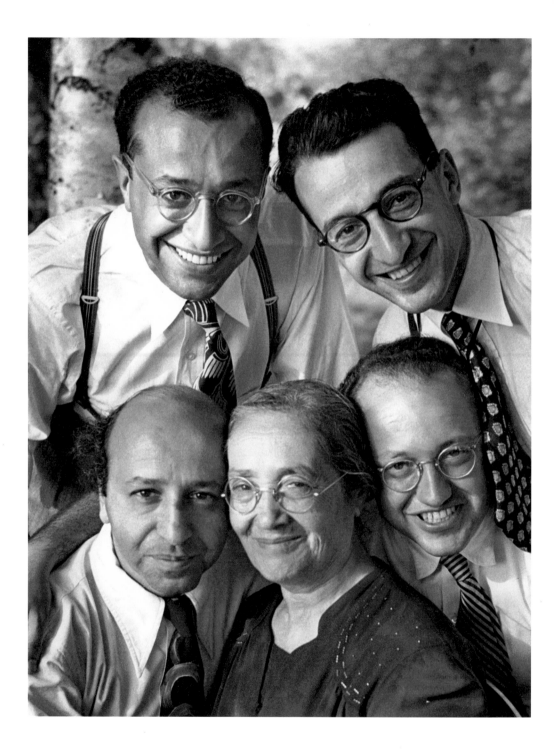

# KARSH

## BEYOND THE CAMERA

*Selected, with an introduction & commentary by* DAVID TRAVIS

DAVID R. GODINE · *Publisher*
*Boston*

First published in 2012 by
DAVID R. GODINE · *Publisher*
Post Office Box 450
Jaffrey, New Hampshire 03452
*www.godine.com*

LIBRARY OF CONGRESS CATALOGING-IN-PUBLICATION DATA

Karsh, Yousuf, 1908-2002.
Karsh : beyond the camera / selected, with an
introduction & commentary by David Travis.
p.     cm.
ISBN 978-1-56792-438-1 – ISBN 1-56792-438-7
1. Karsh, Yousuf, 1908-2002–Interviews.   2. Portrait photographers–
Canada–Interviews.   3. Portrait photography. I. Travis, David, 1948-
II. Title.
TR140.K3A5  2012
770.92–dc23
[B]
2012001545

FRONTISPIECE:
Massih Karsh and her four sons,
clockwise from lower left: Yousuf, Salim,
Malak, Jamil, 1948

FIRST EDITION
*Printed in Lausanne, Switzerland, by Entreprise d'Arts Graphiques Jean Genoud SA*

# CONTENTS

# PREFACE

*When we see a natural style, we are astonished and charmed; for we expected to see an author, and we find a person.*[1]  BLAISE PASCAL

Portraits by Yousuf Karsh have a style unique in the history of photography. His style, which evolved from techniques in stage lighting, is not natural. But it contains something natural that is beyond the artifice of surface theatrics or the allure of the heroes and celebrities he portrays. Any musings the photographer had as his pictures came into being are gone. Karsh's autobiography explains how he came to make his portraits, and his books relate anecdotes about his encounters with famous subjects, but none of his publications reveal what he thought about himself. This is private territory. Nevertheless, we can speculate, as we have attempted to do in an informed way in this publication.

In August and September of 1988, Karsh's long-time studio assistant, Jerry Fielder, sat down with the master photographer and taped hours of recollections about the many portrait sessions and fragments of his transfigured life. Some of Karsh's stories were well rehearsed, because he had been telling them for decades, some provided extra details, and others were new. Listening to the Fielder interviews and other audio or video tapes, one can hear the deliberate and meticulously polite way the photographer deftly weaves the drama of a compelling story into language befitting a courtier. Hearing his accented diction, cadences, and inflections, one's imagination is guided from the subject rendered in the famous image to the person who created it. A voice can do that. His voice invites us to try to fathom the photographer's psyche and conjecture how he thinks and how he feels, just as we might try to determine the character of any storyteller or poet. We imagine the kind of man he is and what it would have been like to have been in his presence. For a portrait photographer, that makes all the difference.

# INTRODUCTION

## I · BEFORE THE CAMERA

*I didn't know I had a birthday, until I came to Canada.*[2]

Yousuf Karsh was born in the Ottoman Empire (now Turkey) in 1908, just prior to the horrors of the first genocide of the twentieth century. The persecution of Christian Armenians escalated at the end of the nineteenth century, and by 1915, the Ottoman Turks had begun systematically massacring the Armenians throughout the empire. From Karsh's boyhood in Mardin through his family's exile to Syria, there was nothing to celebrate, not even the birthday of the oldest surviving son. December 23rd was never a special day until Karsh reached the safety of the small town of Sherbrooke, Canada, where his Uncle Nakash cared for him as if he were his own.

There were no atrocities to face when Karsh arrived in (Aziz) George Nakash's snow-covered village in the eastern townships of Québec. Of all the great photographers whose world he joined in adulthood, none of them had his story. Some of them had escaped from the treatment of Fascist regimes, but none had been witness to the worst horrors like Karsh had as a boy in Mardin. He had seen a dead baby hanging on the hook in a butcher shop. He had been the frightened delivery boy bringing prison rations to two of his mother's brothers, and the nephew who was told to stop deliveries because the jailors had murdered his uncles. He had helped to take care of a young Armenian girl whom his mother had taken into the family after her tormentors gouged out her eyes. The trauma of watching his younger sister's death from typhus during the time when his family was being starved was part of his psychological fabric when he traveled to his new home, as was the reality of her treatment by the starving men who had promised to see to her burial.[3]

Karsh's life in Sherbrooke was an escape from tragedy. Abdul Yousuf Karsh was treated kindly by his classmates, who accepted the exotic looking young man and gave him the nickname Joe. Yousuf had a lot to learn: a new language, a new climate, and a new way of life. He also had to deal with the burden he brought from Mardin and find a purpose for life after what he had experienced there. Those horrors could never be erased from his memory, but his mother gave him a way with which to deal with them. Through her Christian faith, she taught him not to hate, showing him how to deal with the rage for revenge: "If you have to cast a stone, be sure to miss."[4] How that affected his outlook on life is at the core of the story of his career.

Sometimes Karsh remembered his hometown in southeastern Turkey as a kind of Eden. The Tigris River is less than one hundred miles away, and locals like to think of Mardin as being the region of the garden where the Bible locates the beginning of the human race. There were fertile plains before the southern expanse turned into the desert. Fruit and nut trees were plentiful, as well as what Karsh called manna, a green substance that was scraped from the leaves of certain trees, pressed into bread, dried, and chewed. There were other ancient pleasures in the ancient city. On the hot, dry summer nights his whole family would sleep outside on a terrace roof, each one laying on a separate raised platform to protect them from scorpions. Clay water-cooling jugs kept them refreshed, and the stars provided enchantment. As night deepened and the town gazed into the heavens, a seven-year-old girl cousin next to Yousuf and his brothers would "weave fairy tales about ships and voyages and faraway people and marvelous happenings that befell travelers."[5]

(Aziz) George Nakash

Karsh's Syriac Catholic father, Abel al-Massih Karsh, had complex family origins. Massih's supposed Syriac, and possibly Jewish, heritage helped the family to survive in Mardin through the worst of the atrocities. They participated in the Arabic culture (their sons all had Arabic names) and did not isolate themselves solely among the Armenians. When the genocide grew to include Jews and Christian Arabs in 1922, the

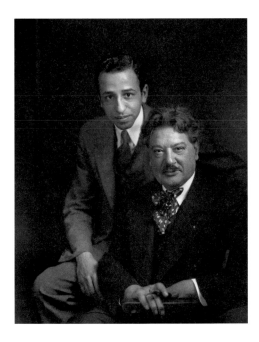

Yousuf Karsh and John H. Garo, 1931

Turkish authorities, who had already confiscated their house and possessions, gave the Karsh family a donkey and forced them to leave Mardin by caravan. They walked through the desert with little more than their lives.[6] With the help of relatives, they managed to re-establish themselves in Aleppo, Syria. At this time, Yousuf's mother and her brother agreed that the best prospect for the young boy would be to guarantee a position for him in Canada. Nakash made sacrifices and borrowed money from Aziz Setlakwe, the uncle who had brought him to Canada, in order to support his nephew. His concerted bureaucratic efforts coupled with personal pleading to the Department of Immigration officials made it possible for Yousuf to acquire the papers necessary to emigrate from Syria to Canada.

When sixteen-year-old Yousuf stepped off the boat in Halifax on New Year's Eve, 1925, he met an uncle who greeted him in his native tongue.[7] Uncle Nakash's Arabic was the only thing familiar about his new surroundings. "We went up from the dock to the station in a taxi – a sleigh-taxi drawn by horses with bells on their harness which never stopped tinkling.... Everybody looked happy, and I was intoxicated by their joy."[8] The trip to Sherbrooke took two days due to a blizzard that stopped the train. The snow and the vastness of the whitened landscape must have seemed more marvelous than any rooftop tale told under the Milky Way.

Karsh spent six months in school and then began working in his uncle's studio. The gift of a Kodak Brownie camera brought out his innate visual talent, and a landscape made with the simple camera won a cash prize when one of Yousuf's schoolmates secretly entered it into a photography competition. "I took ten dollars and I gave it to the young man.... and the other forty went to my parents that they very much needed. But, when I sent those forty dollars it was as if I sent four million dollars because [it was] all I had. And the feeling of it was great; I walked straight for weeks on end."[9] Uncle Nakash also recognized

Yousuf's talent and made arrangements in 1928 with a portrait photographer in Boston for six months of training.

The portrait photographer John H. Garo was also a part of the Armenian diaspora, greatly increased by the genocide. In Garo's stylish studio on Boylston Street, Karsh learned photographic chemistry, optics, and the exacting processes of the exotic printing techniques of platinum, carbro, bromoil, carbon, and gum-arabic. These were physically beautiful prints made by hand and meant to demonstrate that photography was a personal expression and not merely a mechanical image disgorged by a machine.[10]

Beyond technique, Karsh began to be conscious of how to see and use reflectors to shape the light available to him in a studio. He observed how Garo, like his uncle, conversed with sitters and put them at ease. Garo sent him to art classes and had him study the great painters. "I just opened my eyes like a hungry boy to everything I was exposed to, constantly visiting the Boston Museum of Fine Arts, constantly visiting the library, and once a week, or every two weeks Mrs. Garo would invite me to [accompany] her for the pop concert, or on my own with two or three of my companions would go to an opera."[11] The young apprentice was also an audience for the conversation at the gatherings that Garo and his wife hosted in the studio, where the elite of Boston society would gather before performances or dinners to drink flavored bootleg alcohol while chatting with opera stars, conductors, dancers, writers, and patrons. The six-month training session with Garo ended two years later when the fledging photographer was prepared to return to Sherbrooke to assume the role of a professional assistant in the George Nakash Studio.

## II · BEHIND THE CAMERA

*In my case, I must confess, I am trained and I can tell whether there is something beyond that face or not. And that's where I attempt to light that feature in such a way that I can elicit the true character of that person.*[12]

In the Nakash and Garo studios, Karsh saw many celebrities and characters transformed into portraits. At the ripe age of twenty-five, the young photographer felt ready to strike out on his own. He wanted to establish himself in Washington, D.C. and pursue the world leaders and illustrious sitters who populated the city. However, the immigration quota for Armenians in the United States

had reached its limit, so in April 1930, he went back to Canada, where he assisted his uncle in Sherbrooke and then John Powis in Ottawa.[13]

When he was able to open his own studio in Ottawa in May 1933, Karsh had everything but money, reputation, established clientele, a network of connections, and a style. He was, however, well trained in all photographic techniques, and he had seen artificial lighting used in the Nakash and Powis studios. Auxiliary skills were also in place. Garo had shown him how conversation could set the tone of a sitting and determine its results. His uncle had demonstrated that being polite and well dressed brought respect from patrons and the public. It also lent an atmosphere of high purpose to the sitting. Karsh's accent and foreign character were charming, and he used them to his advantage, creating a role for himself as an aspiring artist among the important leaders, visiting statesmen, and society figures of Ottawa. He had ambitious dreams. This was, however, the Great Depression, and it took a substantial loan from his cousins Michel and Cali Setlakwe to establish the Karsh Studio at 130 Sparks Street. Another loan from Uncle Nakash was soon required to keep it going.

The most important conduit to his new future was his association with the Ottawa Drama League. There he had a revelation about the expressive use of artificial lights, and there he found introductions to Ottawa's social and political figures, even to Lord Bessborough, the Governor General of Canada. He also met Solange Gauthier, an actress, director, and cultured French immigrant, who would become his wife six years later. Though Solange was eight years his senior, they were a good match. "They were both New Canadians who wanted to be accepted by the establishment yet were determined to maintain their differences rather than assimilate into the Anglo-Canadian norm."[14] Solange was sophisticated and had connections to the worlds of music, literature, drama, and the dance.

Yousuf and Solange were married on April 27, 1939. The bride, with her business sense, was the administrator of the Karsh Studio, and the groom boasted that his photographic work in the theater had been reproduced in prestigious national magazines as well as in arts publications in London. He also photographed individuals, families, debutants, brides and wedding couples (sometimes eight in one day), graduates, and, of course, babies. There was another side to his work illustrated by the photographs he was taking of Solange. For the most part they were expressions rather than portraits. She appeared in a flowing gown dancing under a willow tree or in sand dunes, as a series of mysterious figures on a dark bottle entitled "Elixir," in costume in various stage roles, or

*Contemplating* (Solange Gauthier), 1935

as a stage character, dramatically lit, contemplating a single candle. When he did make a formal portrait of her face alone, he titled it "Refuge."

Karsh's early professional work had influences from Garo, naturally, but its modern feel came from fashion illustrations and celebrity portraits by Edward Steichen he saw in *Vanity Fair*. In the late 1930s, a style was emerging from the portraits Karsh was making. It became more distinctive as he refined his sense of how to light the face to bring out what he called the subject's true character or "inner power." His best portraits of this period were detailed and carefully modulated, contrasting highlights and shadows akin to the stage actors he had seen emerging into light from darkened backgrounds in the Ottawa Little Theatre. Within a decade his easily identified style and intense way of working resulted in the coinage of a new verb: "karshed," which is how Field Marshal Bernard Montgomery characterized his experience (reddened eyes and all) after an hour under the lights in the studio on Sparks Street.[15]

Sometimes Karsh made journalistic photographs. A photograph of the Canadian Prime Minister hosting Franklin Delano Roosevelt during a 1936 visit to Québec led to a friendship with William Lyon Mackenzie King. Through the long-serving Prime Minister, Karsh received his most important introductions. Mackenzie King took the initiative in arranging the 1941 session with Winston Churchill, and when the "roaring lion" portrait was published in Canada, Great Britain, and the United States, Karsh instantly burst onto the stage of international fame.

Mackenzie King arranged for Karsh to travel by naval convoy to Great Britain in 1943, where he photographed more than forty political and military leaders, as well as writers and artists. He was commissioned by *Life* magazine after the war's end to photograph American leaders in Washington, D.C., then world

leaders in San Francisco at the United Nations Conference, as well as captains of American industry throughout the country. From this portfolio, Karsh selected the seventy-five individuals included in his first book *Faces of Destiny* issued in 1946.

With another major commission from *Life* magazine to photograph Hollywood stars, Karsh's international career was secured and shifted its emphasis from war-time subjects – heroes in a traditional sense – to men and women of talent and accomplishment, and occasionally of mere celebrity. In Hollywood, he used and contributed to the development of the *film noir* style of lighting that was in vogue. Despite his diligence in trying to get beyond the façades of the personas of well-known actors and actresses, he was seldom allowed full release from their make-believe world. His encounters with them as people always brought him back to a desire to ennoble his subjects.

By early 1948, Karsh, with the urging of Uncle Nakash, approached those with whom he had strong connections in the government to help with the formal immigration of his family from Syria to Canada. He had already brought his brother Malak to Canada in 1937 and set him up as a photographer. Now with the political situation deteriorating in Aleppo, it was time for him interrupt his hectic schedule of work and travel in order to bring his family together in the safety of his adopted country. His connections in the government proved to be substantial, and it took but two weeks for a special Order-in-Council to allow for their admission. After Nakash purchased a modest house for Massih and Bahiyah outside of Québec City in Sainte-Marie-de-Beauce near another relative and Yousuf helped place Jamil, who had earned a medical degree in Beirut, in a leading New York City hospital, Karsh's manic schedule began again. In the next decade, he would produce some of his finest portraits and his fame increased further.

In May 1958, *Popular Photography* magazine listed Karsh among the ten greatest photographers in the world.[16] His star rose further in 1959 when *Portraits of Greatness* was published. It contained ninety-six full-page portraits reproduced in photogravure, which enhanced the dark tones that were the hallmark of Karsh's exacting and characteristic printing technique.[17] The impressive list of sitters, from Albert Einstein and Helen Keller to Albert Schweitzer and Ernest Hemingway, demonstrates how busy he was during the eighteen years after the Churchill success. Each plate faced a textual anecdote about the sitter and the session. The book was a critical and commercial success and served to define Karsh's style. His books of portraits that followed for the next seventeen years

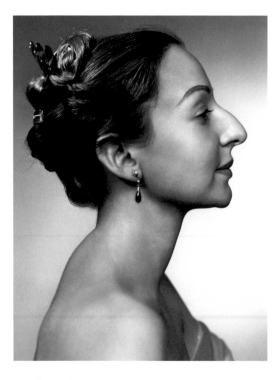

Estrellita Karsh, 1963

were for the most part updates of this format, pairing text with portraits in alphabetical order.

*Portraits of Greatness* included a second Churchill portrait from 1955 of "the aged, tired, but immortal"[18] war leader. It demonstrates how a sitter changes with age and how earlier portraits that tried to capture the individual's essence were momentary ends of a particular evolution of responses elicited by the photographer at a specific time. Still there is something in both portraits that is quintessentially Churchill.

The second Churchill portrait shows that when a photographer looks hard into the subject, the subject often looks back, registering the encounter in his or her face. The subject signals the presence of the agent making the photograph, and that reaction may mask the subject's natural facial expression. That interchange, however, is a necessary element in the work of all great studio portrait photographers. It takes them beyond the lights and the camera and marks the encounter as the essence of the portrait.

In 1959, Karsh suffered a heart attack from over-working, his mother died, and Solange learned she had cancer. Up to Solange's death in 1961, she worked with Karsh on his autobiography that would be published by Alfred A. Knopf. It was something she wanted to do for him, as she knew that there had been very few autobiographies of photographers published. Even Edward Steichen's *A Life in Photography* did not appear until 1963. As tragic as the loss of Solange was, Karsh had a lucky star appear. He met Estrellita Nachbar during a portrait session in Chicago and was attracted to the intelligent medical historian and writer. They were married on August 28, 1962 and a new chapter in his life began.

Karsh's portraits of Estrellita are no longer the experiments searching for what the medium of the camera could express - traits that characterized his photographs of Solange. That aspect of his style had been refined and settled. An early portrait of his new bride is almost worshipful in its serenity and grace.

Her profile is inhabited by deference, esteem, and adoration like those profiles of the contemplative François Mauriac, the stoic Georgia O'Keeffe, and the radiant Grace Kelly.

Estrellita would be his guide. It was something Karsh needed. Uncle Nakash and John Garo had been teachers more than guides; they had prepared him technically and set examples of what a professional portrait photographer could be. Prime Minister Mackenzie King had been a friendly facilitator who opened doors to the remote world of politicians and national rulers. But it was the three great women in Karsh's life who were his psychological companions, guiding him beyond the camera and the medium. His mother, Solange, and Estrellita channeled his emotional currents and sense of self into a force directed toward benevolence, accomplishment, and confidence. Once he became famous and respected, he needed to reconstitute the initial immigrant aspirations that had brought him onto the world stage. With her innate sophistication and her authorial sense of order, Estrellita would become the companion and pilot Karsh needed, allowing him to maintain his self-possession but ease the strictures of a style that had become a brand.

## III · BEYOND THE CAMERA

*I had the reputation of being unusually courteous myself. . . . I would stand and smile and bow through all the points of the compass. This always seemed to please everybody . . . perhaps because it was the only thing I could do really well and which they all could understand.*[19]

The basis for Karsh's interpersonal skills as a conversationalist and confidant in studio sessions accompanied him to the new world in nascent form. Its early manifestations made themselves evident to his Canadian classmates and teachers through his behavior. Throughout his career, his courtesy and attentiveness were qualities every acquaintance or sitter remembered with pleasure. It was something he had learned from his parents and his family situation in Mardin. When you met him, he would offer his hand and bow his head slightly. His attention was always on you; no one else mattered. That is the singular trait that every great portraitist must possess. After that may come a technical skill set and a way of using it, something we call style.

Style, essential to a professional photographer's identity and way of

working, is more than a visual signature. It can be the sum of one's limitations or a statement of the triumph of characteristically negotiating the world with the tools at hand. In Karsh's case, it may have also been a reaction to a world that once had its way with him. From childhood, his first dream was to be a physician. His idea was to make the world a better place through healing. "Basically, I think I'm of equal service to humanity . . . Sometimes I find myself in the role of psychologist, sometimes psychiatrist, although I don't take it seriously. But the idea is that I'm able to help people while I'm photographing them."[20]

Even after becoming a photographer, that humanistic goal was not forgotten. He wanted to honor men and women of special achievement, those who were shaping the world, and those who had great positive spirit. Perhaps he thought his efforts could prevent the world he had once known in Mardin from re-emerging. That attitude is obscured when we think of Karsh as a hero worshipper, a characteristic he fully and freely admitted. But, he could, and did, see beyond celebrity and not be sidetracked by his subject's vanity.[21] In interviews he repeated to his dying days, "I don't think that I edit at all. I photograph what I see, and all that goodness is there."[22]

Cynics might consider this statement a cloak to disguise a portrait photographer's need to flatter. And to be sure, flattery is an element of a successful private studio practice. In the case of an accomplished master, however, this oversimplified position hides the relationship between photographer and sitter that can give rise to spontaneous results, which come from working in partnership. Such a position also dismisses the innovative urges particular to pose and lighting with which the photographer may be experimenting. And most importantly, it ignores the essential ingredients for even modest success: a gift for interpersonal exchange and an inquisitive temperament.[23]

Karsh was well aware of the charge. At the end of his career when fame had long been his and clients were booked more than six months in advance, he admitted that his sitters "expect to have the experience that I am prepared to give them."[24] During the session they were stimulated and admired, but what they really hoped to see was an expression of their better selves. Karsh was always generous in that way. He was also trustworthy. His sitters opened themselves to him, and he to them. Through conversation, he brought out the private expression in the sitter's character with few traces of the public mask. This had nothing to do with the latest theories of art or appetites for creating new fashions in portraiture. Style was only an accompanist to the enterprise. What was essential in Karsh's approach was to employ his best lighting and to see his sit-

ters in their best light. He tried to attain a circumstance described centuries before by Michel de Montaigne: "A generous heart should never disguise its thoughts, but willingly reveal its inmost depths. It is either all good, or at least all human."[25] This sentiment is a distant echo of what his mother taught him: that people are people and must be forgiven.

The Montaigne quote is also an apt description of both the sitter and the photographer when a Karsh session went well. This sentiment justified maintaining his approach to making portraits while not radically altering his style as fashions came and went. At the end of his career, when it was suggested that his style had become old fashioned, he retorted, "The human face has not changed since the day I was born."[26] If the human face had its inherent stability, so did he.

Karsh's mother, a devout Methodist, formed his early outlook on life during the Armenian genocide and taught him that all people share a common humanity. This was his psychological foundation. If we couple that with his sense of mission, we see why there could not be another photographer even remotely like him. For Karsh, the distance between what each of us has in common and what makes us unique provided his territory for exploration, for communicating character, for rendering esteem.

We ordinarily think of artists as beings whose imaginations set them apart from the rest of the world. Karsh was that. But in other ways he was a man who was comfortable finding and celebrating what others shared and liked. He was a dividual being, to use an archaic word. We always refer to artists by the term individual, meaning, at its root, indivisible, idiosyncratic, or singular. We have no term for artists whose extraordinary transforming experiences in their formative years bring them closer to commonness with others. This insight gives us a particular way to see Karsh's photographs. When we look long and beyond subject and style, we see his portraits as the works of a searcher for the common good and a healer. When we acknowledge and then temper our view that portraits of others must always symbolize the state of our own anxieties, and when we recognize and then restrain our demand that photographers expose truths in others that we guard in ourselves, we understand better the reason Karsh created his portraits the way he did. We might even convince ourselves that there are memories of experience, apprehension, and worth that are alike in all of us, and realize how crucial it was for Karsh to show us what they are.

*On the following pages, the transcribed words of Yousuf Karsh appear at the top of the page, followed by David Travis's commentary.*

# PLATES AND COMMENTARY

It seemed that [the poet] Duncan Campbell Scott wrote a tribute to welcome the Queen and King George VI to Canada. It made quite an impression on the radio. Mackenzie King being with the royal couple [had not heard it], he arranged a special dinner for the poet. And he invited a few interesting people, and was looking for a very colorful, interesting evening. Colorful it was, because after dinner, Mackenzie King sat at the piano to entertain his guests with his favorite pet, his Irish terrier, Pat, beside him. Usually as Mackenzie King makes musical notes on the piano, Pat likes to sing with him. This time Pat wouldn't sing. He tried again and again. Finally in sheer disappointment he said, "Alright Duncan, let's have your poem."[27]

*Karsh made several attempts to take an engaging portrait of Mackenzie King. The Prime Minister was overly concerned about how history would see him and was unable to offer any more than an immobile, formal face to his favorite photographer. He was less self-conscious with his dog, and Karsh had better success with snapshots of the politician relaxing on his estate. Mackenzie King dominated Canadian politics from the 1920s through the 1940s, and was the major advocate in Karsh's initial rise to international recognition. They first met in the summer of 1936 when Karsh photographed him and Lord Tweedsmuir (John Buchan, the Governor General of Canada) greeting Franklin Delano Roosevelt and his son James on their visit to Québec City. The journalistic photograph pleased Mackinzie King, and he pledged his support to Karsh. Years later, he allowed Karsh to secretly set up his lights in the Speaker's Chamber to secure a portrait of Winston Churchill after his stirring address to a joint session of the Canadian Parliament on December 30, 1941. This was the photograph that almost instantly made Karsh internationally famous. Mackenzie King also arranged for transport in a naval convoy and wrote letters of introduction in advance of Karsh's 1943 whirlwind photographic tour of London. The letters seem to have opened every door, even the royal one at Buckingham Palace.*

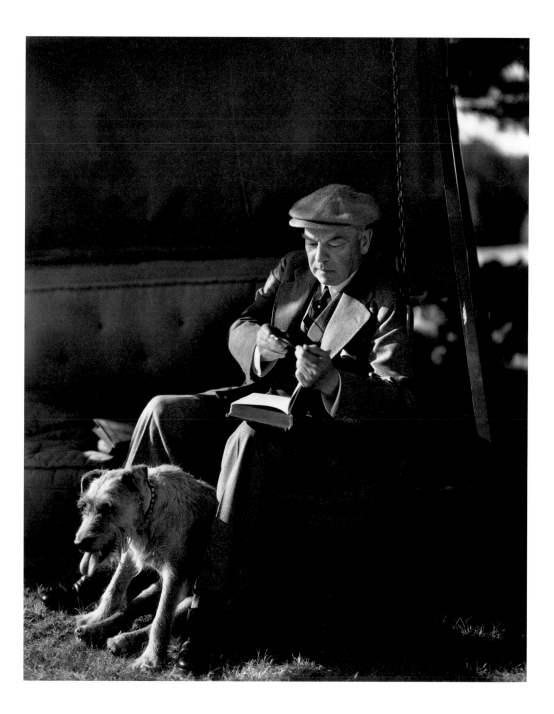

WILLIAM LYON MACKENZIE KING · August 21, 1940

*Prime Minister of Canada (1921–1926, 1926–1930, 1935–1948)*

[Canadian Prime Minister] William Lyon Mackenzie King said, "Karsh, we have put a few minutes aside for you but we are not going to tell the great man. Set up your camera in the Speaker's Chamber." And true to his promise, arm in arm with Churchill [Mackenzie King] came to the Speaker's Chamber. I switched on my lights and immediately Winston Churchill was taken by surprise. He said, "What is going on?" And I said, "Sir, I hope I will be fortunate enough to make a worthy photograph of this historic occasion." He banged at the nearest table he could. He said: "Why was I not told?" His associates and entourage laughed, and that did not help matters at all. He was given a fresh cigar, and he was chewing at it rather seriously and resenting the whole situation. Ultimately, he said, "You may take one." I immediately went to him with an ashtray, and I said, "If you please, sir." He would not hear [of] removing the cigar from his mouth. Immediately I went back to my camera to make sure everything was ready. And without any premeditation but with infinite respect, I took the cigar from his lips. By the time I get back the four feet I was from the camera, he looked so belligerent he could have devoured me. Immediately with a great smile, he said, "You may take another one." And this time, he straightened up; he looked very benevolent, very benign. I took a second one. He walked towards me and shook me by the hand and said, "You can even make a roaring lion stand still to be photographed."[28]

*This photograph began Karsh's international career, and he told the story until his death. Every interviewer, dinner guest, head of state, movie star, musician, scientist, writer, artist, or businessman that he photographed wanted to hear the story. And Karsh was happy to oblige. It is after all his story more than the sitter's. Karsh often liked to add the light addendum: "... it was my great privilege to photograph him and I have not had any rest ever since."[29] Charming, and true.*

WINSTON CHURCHILL · December 30, 1941

*Prime Minister of Great Britain (1940-1945, 1951-1955), Politician*

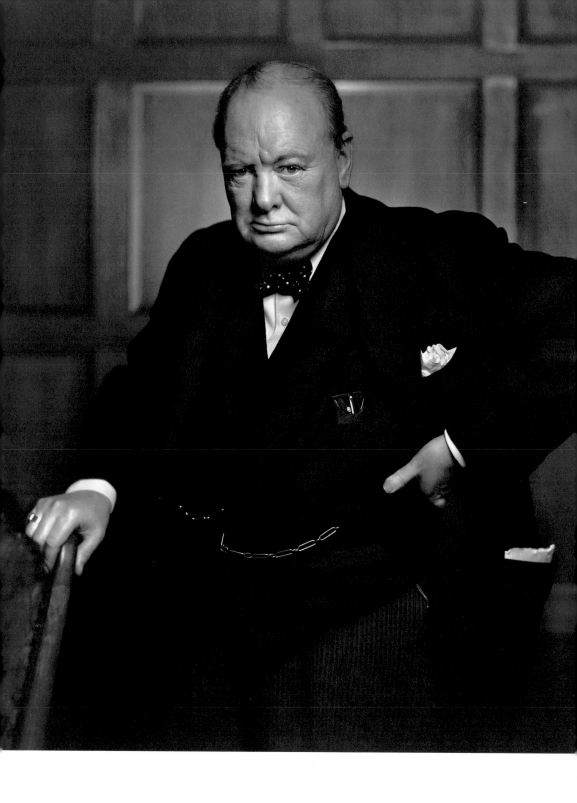

My favorite subject of all has doubtless been Winston Churchill. I had a second "shot" at him in 1955, when he was given the Williamsburg Award. This award ... was to be made "to a person who in the course of contemporary events has made an outstanding contribution to the historic struggle of men to live free and self-respecting in a just society." He did not appear to recognize me at first, but during the brief waits for the power to build up between electronic flashes, I gazed at him to see what changes time had wrought, and he was looking at me.[30]

*Some may see in this portrait the degree to which war-time leadership can waste a face. Others may gauge the wreck of two strokes and several political defeats. Photographers will spot the unflattering effects caused by the lack of a modulating fill light and a small strobe light etching into the face. During the ceremony, the former Prime Minister was all smiles. Here his ravaged face with his bloodshot eyes stares hard ahead as steadfast as ever and unforgiving. Perhaps he was seething as he recognized Karsh as the impertinent young Canadian photographer who had disarmed him of his cherished cigar. But this is speculation. What we do know is that Karsh befriended Churchill's son-in-law at the portrait sitting during the Williamsburg Award Ceremony in Draper's Hall, and the two set up a private portrait session at Churchill's home. A time for a sitting was specified and Karsh was elated. Suddenly, it was cancelled by Churchill's secretary who said, "Sir Winston recalls that in Ottawa you treated him somewhat cavalierly - something to do with a cigar."[31] But ever the man to find a positive point of view, Karsh wrote in his autobiography, "I doubt if Sir Winston really harbored a grudge against me.... He might well not have wished, at his age, to be subjected to a long photographic session, and used the excuse of the cigar incident as a little joke on me."[32] Only a sainted mother could have been more forgiving.*

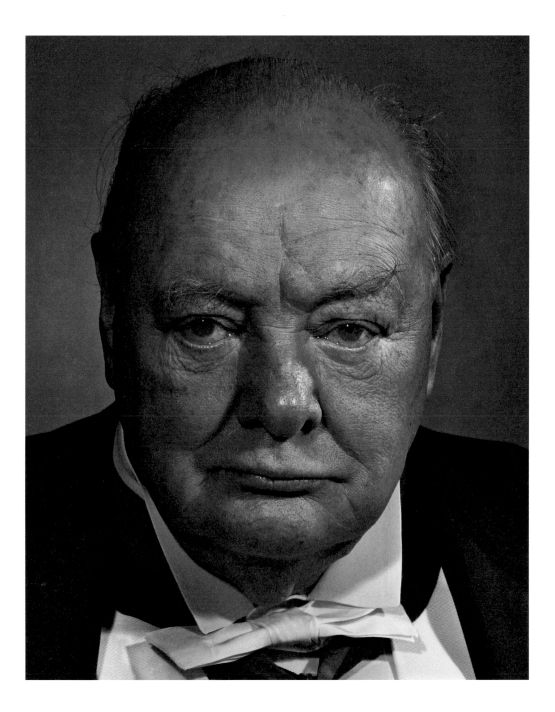

Winston Churchill · December 7, 1955

*Prime Minister of Great Britain (1940-1945, 1951-1955), Politician*

Wellesley-educated daughter of the powerful Chinese Chairman, T. V. Soong, and wife of Chiang Kai-shek, President of the New Republic of Taiwan, she was strong willed, beautiful, and accomplished. She could spare only a few moments for photography and was concerned about how she looked. If she seems graver than in her countless other photographs, I felt that her appearance was only incidental to the great influence she wielded on her country and international affairs.[33]

*Karsh wanted his sitters mentally active. He did not want them relaxed. This took preparation - having tea the day before, listening to them speak, or watching them perform - so that they could have a spirited conversation during the sitting. Despite Madame Chiang Kai-shek's busy schedule, Canadian Prime Minister William Mackenzie King arranged a short time for this portrait, hoping Karsh would produce a result similar to his four minutes with Winston Churchill. Mackenzie King even helped by standing outside of the picture so that Madame Chiang Kai-shek, or the Missimo, would have a place to direct her eyes. With a bank of lights behind him, she flirted with him saying, "Mr. Prime Minister, you dazzle me." [34] Part of her allure was that she spoke English fluently with an accent acquired during her studies at Wesleyan College in Macon, Georgia. She also knew how to act within a man's world of politics. During her speech she removed her jacket and gave it purposefully to a bedazzled Mackenzie King as she took the podium. Try as Karsh might, he could not force every exposure to reveal a personality, especially if the sitting was short. Thus, we are left to imagine the Missimo's lighter self. Evidently, it came and went and reappeared when she needed it. Maybe Karsh missed his chance when she joked, "I am sorry gentlemen, I do not smoke cigars," [35] and then assumed her formal pose, playing her other role, the one Life magazine defined as the most powerful woman in the world. The portrait does succeed in that regard as it aligns well with how others would later describe her: as the most powerful leader China never had.*

MADAME CHIANG KAI-SHEK (MAY-LING SOONG CHIANG) · June 15, 1943

*First Lady of the Republic of China, Politician*

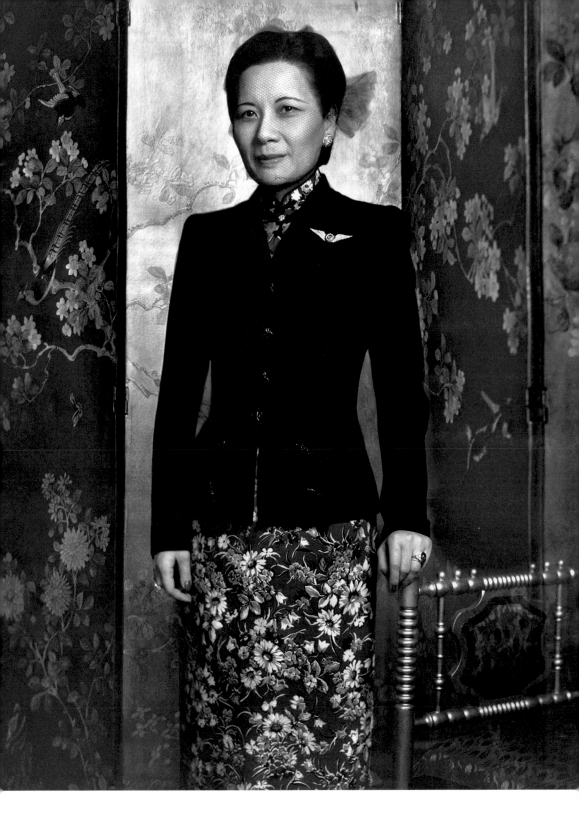

When I am asked who was the most exciting and interesting person I've ever photographed, among the first names that come to my mind is the name of George Bernard Shaw, for he was at once scintillating, inquisitive, sarcastic, sardonic, but always supremely witty. He made a practice, whether conscious or otherwise, to be very provocative when you [were] in his presence. But it was all done to make the occasion exciting and stimulating. He said, "May I ask what your nationality is?" I said, "Armenian." "Oh," he said, "wonderful. I have many friends among the Armenians. But you know the only way to keep them healthy and strong is to exterminate them once in awhile." Well, I did not take offence. . . . Ultimately, I understood he did that [for] mental, intellectual excitement. There was no menace meant by it.[36]

*Karsh must have had to take a long, silent breath when he heard Shaw's Armenian comment. It must have hurt. But he remembered that when the quip was communicated to William Saroyan, who was of Armenian heritage, the writer said "Do not take offence, that is Shaw at his best."[37] Still, it was a formidable challenge to play any game of wits at Shaw level. No one was immune to his audaciousness. Shaw knew something about Karsh's profession too. The playwright was an excellent amateur photographer and had witty observations on taking and sitting for portraits. After posing nude for Alvin Langdon Coburn in the role of Rodin's famous sculpture Le Penseur he said, "Though we have hundreds of photographs of Dickens and Wagner, we see nothing of them except the suits of clothes with their heads sticking out; and what is the use of that?"[38] Karsh manners were not ruffled. He countered Shaw's wit with his patience and courtesy, which were equally formidable, and Shaw met his match. Initially, Karsh had been given five minutes for the session. Karsh asked Shaw for ten. "When I said five, I meant ten," Shaw riposted, then added, "When you say ten you probably mean a half an hour. This is likely to end with you taking all the time you want."[39] So it turned out, most fortunately, as both photographer and sitter enjoyed every second of their stimulating head-to-head.*

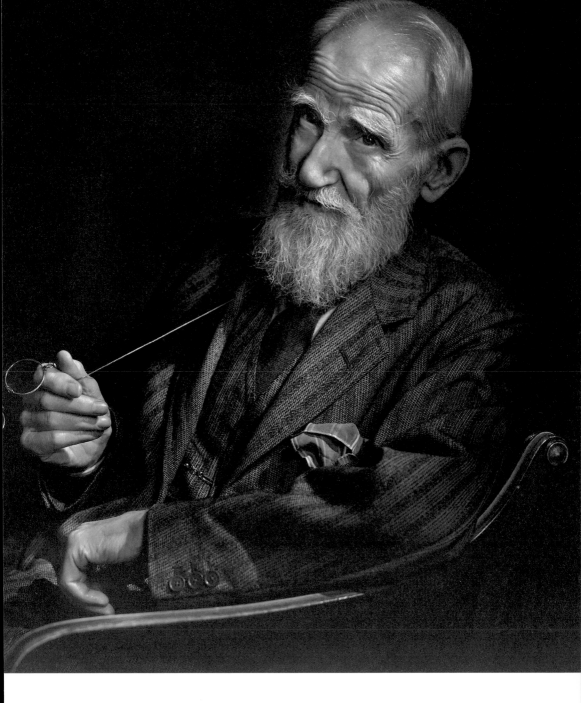

GEORGE BERNARD SHAW · Fall 1943

*Playwright, Journalist, Novelist*

This was the way Wells greeted me: "I hear that you have been photographing Shaw. It's a great mistake. When future generations go through the ruins of London, they will find Shaw, more Shaw, and still more Shaw photographs, and the unfortunate thing is that they will take him to be the typical Englishman." I smiled. "There's nothing funny about it," said H.G. "It's horrible and true." I hastened to explain . . . his remark reminded me of two American radio comedians, Fred Allen and Jack Benny. "I know them," retorted Mr. Wells, "and don't imagine they originated public feuding. Shaw and I have been at it almost fifty years."[40]

*Karsh was busy during his two-month stay in London, running from suburb to city center photographing sixty military, political, and cultural leaders. In H.G. Wells's apartment in Woking, he found the chairs in the drawing room had been pushed in front of objets d'art to protect them from aerial bomb blasts. London was on the front lines of a modern war, almost like the war that Wells had envisioned in his 1907 War in the Air. The threatening invasion of the Nazis paralleled another Wells novel, War of the Worlds, in which Martians invade the heart of the largest military and colonial power on the globe. The future filmmaker Orson Welles dramatically broadcast a CBS radio adaptation of that famous 1898 novel in 1938. He took on Wells's journalistic writing style so convincingly that many people took the fantastic descriptions to be real. It wasn't what it seemed, like Karsh's portrait of Churchill. Most viewers took the great British Prime Minister's defiant demeanor to be the true Churchill, a stone wall of strength, rather than the scowl of a weighty, sartorially resplendent gentleman in a wood-paneled reception hall who had just had a cigar plucked from his mouth. It is improbable that sitter and photographer talked of such parallels. Still, it is good to be reminded that there is often a secret origin to the work of writers and photographers that is as curiously real, we might say, as fiction.*

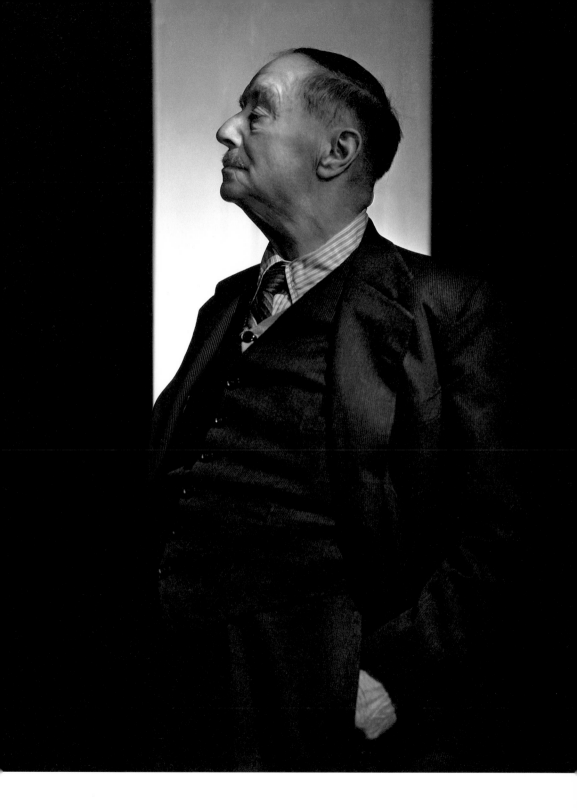

H. G. WELLS · Fall 1943

*Novelist*

"Sir, I would like to make a sympathetic portrait of you." He said, "Sympathetic towards whom?" He was sure, as anything in this life, he had no competitor and he would soon make it to the White House again. It was his optimistic attitude that I enjoyed very much. I found him to be engaging and delightful company. His confidence proved to the world that he was right; he did not need the sympathy.[41]

*When consoling Eleanor Roosevelt on the loss of her husband, President Franklin Delano Roosevelt, Truman asked if he could do anything for her. She replied, "Is there anything we can do for you? For you are the one in trouble now!"[42] During his fifty days as Vice President, he was not part of Roosevelt's confidences or war plans. He was told nothing about developing a working atomic bomb, though dropping the first one used in warfare would become his decision. The pose of straightening his glasses just happened and was not directed by the photographer. It created an air of both a visionary and a focused, practical person. Other Karsh photographs show Truman differently. One interviewer compared those later interpretations to "that shrewd and knavish sprite" Puck, the comical servant in Shakespeare's A Midsummer Night's Dream, who causes all kinds of trouble.[43] Seeing the same subject as both visionary and impish is reason not to trust every expression created between sitters and photographers. We mislead ourselves by believing such well-crafted appearances are the distilled essences of their subjects. This portrait was made while Truman was still a senator from Missouri. He was skeptical, but sincere, unaffected, forthright, and honest as Karsh remembered, which seems more in line with this image. Karsh also described him as "impulsive, and uncomplicated," which only complicates him further.[44] For a photographer, each exposure is of a moment. Sometimes Karsh waited for expressions to unfold, and sometimes circumstances chose for him. As every portrait photographer knows: essences are illusive, but if you must seek one, at least find a mood with which to start.*

HARRY S TRUMAN · March 28, 1944

*Senator, Vice President, President of the United States (1945-1953)*

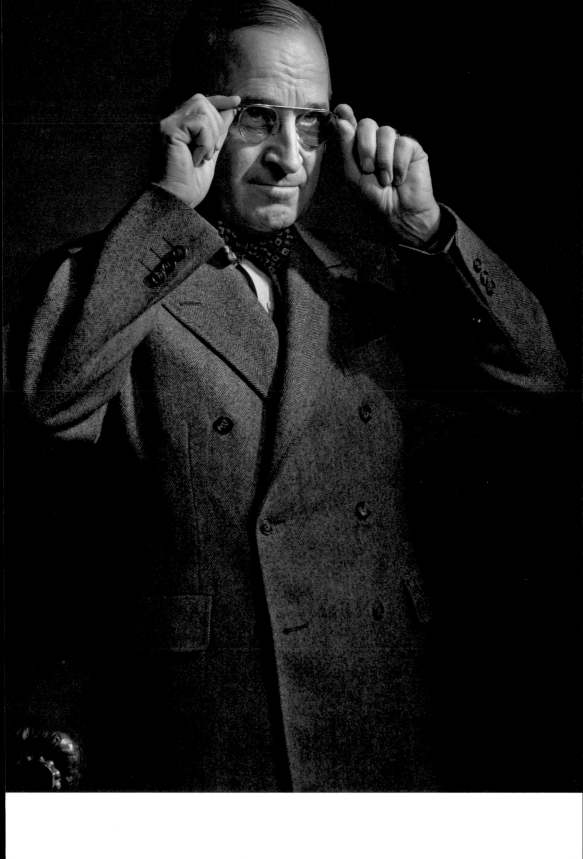

General George [Marshall] said, "You know, Mr. Karsh, the one that I would like you to photograph is not myself as much as my faithful aide, a black man who was in the service for many, many years." And that touched me, because he was [considered by Marshall to be] the most trusted man in the Pentagon. This was James McIntosh, a highly trusted person [with] that faithful expression and the way he holds that diplomatic pouch so tenderly. Doesn't he look beautiful?[45]

*James McIntosh traveled from his home in Washington, D.C. to New York City for this portrait. Karsh photographed him in the Gotham Hotel, where the photographer was staying. It was a time when African Americans were not allowed in the hotel's guest rooms. Karsh was likely empathetic to the situation because his initial immigrant status in Canada gave him the experience of being an outsider. So, Karsh made arrangements in advance and met Mr. McIntosh at the hotel's entrance so as not to upset either party. Still, they were required to take a separate elevator to his room, which he had transformed into a studio. The man who sat for Karsh had been a humble public servant for every military chief of staff since 1918 and was now retired. He was an honored man with many letters of praise from the highest military ranks, including Generals Eisenhower and MacArthur, and a citation from General Marshall. The photographer easily perceived the strength and sensitivity of the face of the steadfast aide, but he also saw another symbol of his character equal in visual impact and grace, his hands. The hands may have been something the numerous generals never noticed, but to a photographer they told as much about the guarded care he took of the nation's most sensitive information and communiqués as his face, and thus they became an essential part of Karsh's own photographic citation of praise.*

JAMES McINTOSH · October 9, 1945
*Chief Messenger of the Office of the Chief of Staff of the United States*

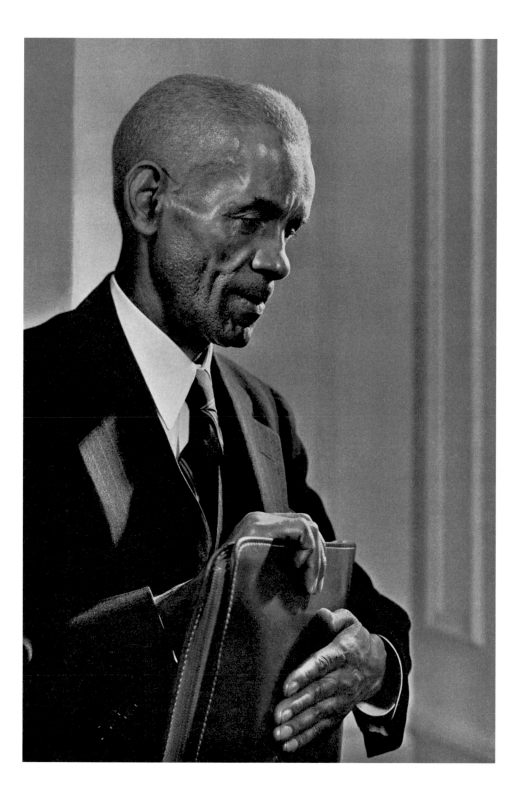

We had a letter from Vietnam from an American soldier asking if he could buy a photograph of Eleanor Roosevelt. We sent one with our compliments, and I asked why a young soldier should be interested. He replied that he was not young, but a veteran, and how wonderful Eleanor Roosevelt was in paying him a visit in the hospital during the war (World War II). He wrote: "As she entered, we thought her to be the homeliest woman we had ever seen. But by her sympathy, her consolation, and her assurance that she herself would telephone our mothers, our fathers, our sweethearts, when she took her leave, we thought her to be among the most beautiful women ever."[46]

> As a civil rights advocate, Eleanor Roosevelt was outraged when the Daughters of the American Revolution (DAR) refused to grant Marian Anderson permission to sing in Constitution Hall to what would have been a mixed racial audience. Such audiences had presented a problem in the past because the African Americans had to be seated or stand in the back. Roosevelt promptly resigned from her membership in the DAR and helped to arrange for the contralto to sing on Easter Sunday 1939 from the steps of the Lincoln Memorial to an audience of 75,000 and millions listening by radio broadcast. The DAR later apologized and Anderson sang at Constitution Hall on several occasions, one of which was a benefit concert for war relief in 1942. Karsh was, and would be, impressed by many of Eleanor Roosevelt's other accomplishments, one of which was helping promote the formation of the United Nations. In this White House sitting, however, Karsh was enchanted with something physical: her hands. He even took a separate photograph of them during the sitting. "[Hands] open a new window to the character. Eleanor Roosevelt was the first to wear so many rings on her fingers. She had the very happy practice of utilizing her hands, which were very picturesque and very decorative."[47] Beautiful, even.

ANNA ELEANOR ROOSEVELT · October 31, 1944
First Lady of the United States (1933-1945), American Delegate
to the United Nations General Assembly, Author, Lecturer

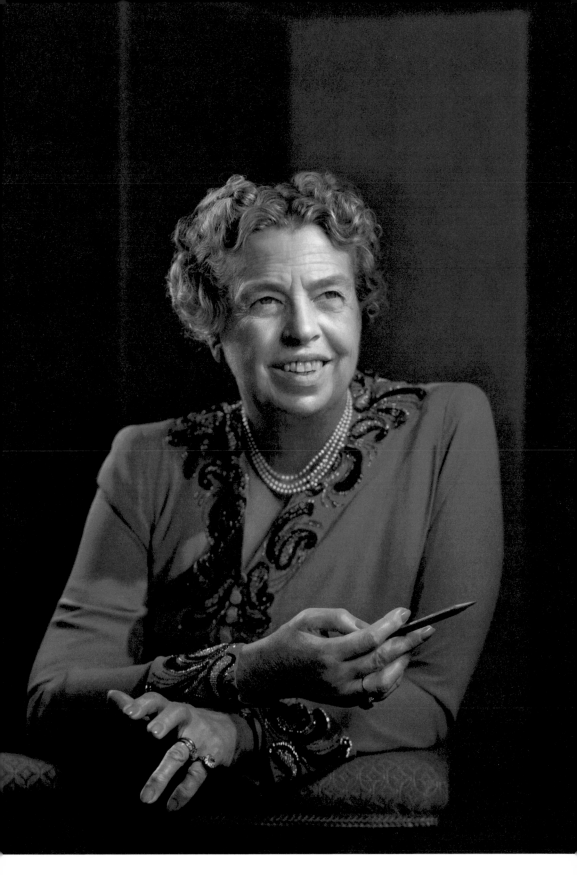

I'm told on good authority [that] as a young singer she paid a visit to Helsinki to pay respect to Jean Sibelius. He had many other visits from young artists, so he quickly in his hospitable manner told his household to please prepare tea. And then he invited Marian Anderson to sing. He said, "Please you may start." And the moment he heard the first note he said, "Make that champagne."[48]

Before Anderson left after her visit with Jean Sibelius in 1933, the composer added one more homage: "My roof is too low for you."[49] Others had praised her extravagantly. The conductor Arturo Toscanini declared she was a singer who only came along every one hundred years. But, dramatically visualizing a voice was not what Karsh wanted from this peaceful and modest contralto. Her suffering from racial prejudice paralleled Karsh's experience as a boy witnessing the slaughter of his fellow Armenians by the Turks, and he felt he and Marian Anderson might be kindred spirits. Judging from the results, one can speculate that Karsh wanted his portrait of her to be not just of a good person but also of a persevering soul, even a saint. An early exposure of the session shows her in prayer, looking up into the light. It was overtly stereotypical, staged, and artificial, which was always a risk in working in the way Karsh chose to photograph. "None of my early shots satisfied me in the least. . . . Then, Miss Anderson's accompanist came in for a rehearsal. I asked him to play the accompaniment to "The Crucifixion," one of the singer's favorite compositions. She began to hum to herself. Hurriedly, I snapped the camera."[50] Getting back to the music itself eliminated the high drama and showed what could radiate from within. No acting was required, just humming notes learned by heart by someone who could bring her audiences to tears. The ideal that Karsh insisted upon for Anderson was audacious. It lifted the portrait from being a sentimental symbol to being one of the great portraits of the era. Out of a reality he knew all too well, Karsh created a simple metaphor, which is often the only way the intellect can give such a subject any attention at all.

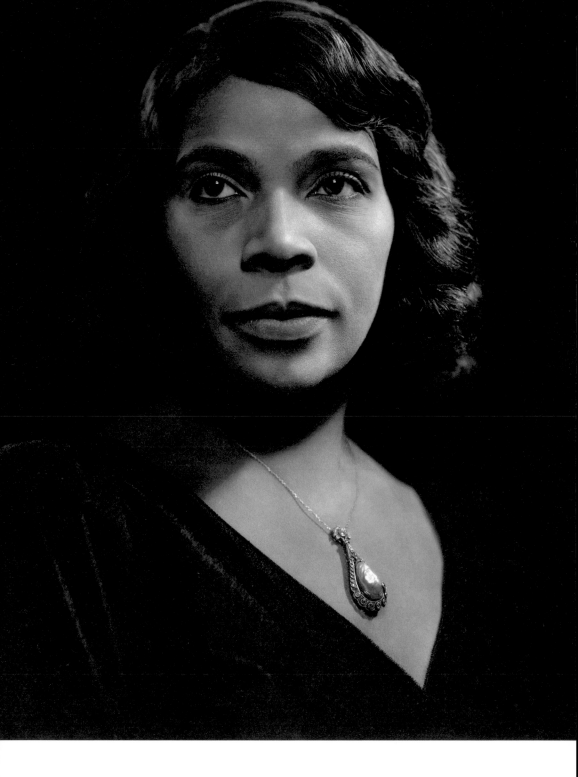

MARIAN ANDERSON · December 9, 1945

*Contralto*

The monster of *Frankenstein* lived a secluded existence in a modest room of the private club in which I photographed him. Gentle and scholarly, with an exquisitely modulated voice, he spoke of English gardens and growing roses.[51]

*In our culture of media narratives, photographic images perpetuate the personae that movie stars, their producers, and their publicists craft for public consumption. In promotions, stars are faces first, then personalities and gossip. When Karsh first came to Hollywood in 1946 on an assignment for Life magazine, he felt he could reveal their other traits. It was a challenge. "I find [with] actors and actresses [it is] more difficult to get them to be unaware of the process going on."[52] Unlike busy politicians, Hollywood actors gave Karsh lots of their time and invited him to lunches and parties, knowing they had a professional stake in how they appeared in America's most popular magazine. Karsh's initial goal of finding the human side of these celebrities was not a naïve quest. In the case of Boris Karloff, the photographer placed the actor's eyes in the darkest part of the lighting scheme, a reference to the creative make-up artists who concocted a famous icon of horror in Frankenstein. But, Karloff was gentle, even scholarly, and thus the portrait reveals his self-reflective character as well. We can imagine Karloff reminiscing about his eighteen years as a struggling actor on stages in the Canadian provinces, which he and Karsh likely discussed. Still, the dramatic film noir mood and the low angle overwhelm the photograph, supplying the requisite mystery that viewers expected. But the sitter does not threaten us as Frankenstein. We can see hints in his eyes of his other identity, the one that signed his checks and contracts with his given name, William Henry Pratt.*

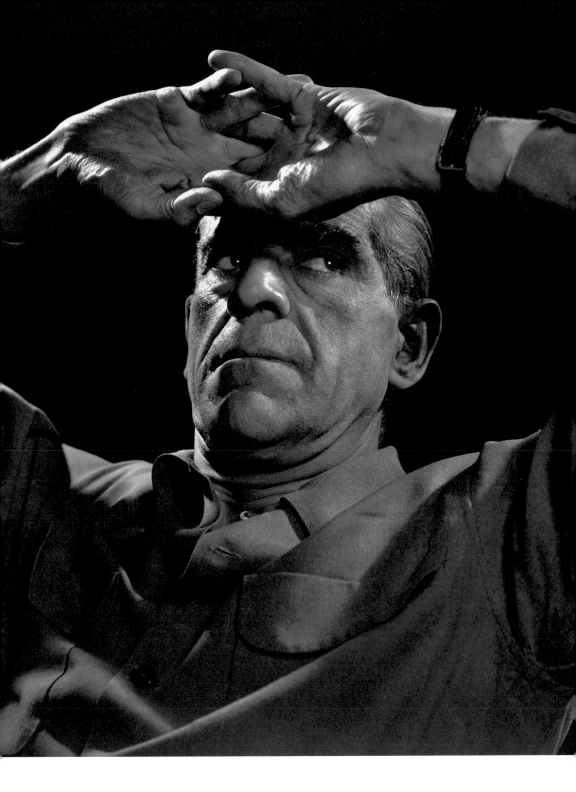

BORIS KARLOFF · 1946

*Actor*

He was among the good-natured people I knew, but almost invariably took the role of a menacing person. This photograph, gesturing with a lit cigarette with the smoke creating this interesting pattern, was the result [of] having made other photographs of him. We sat down to have some cheese and crackers and a glass of wine. Suddenly, I noticed that the lamp created a certain light effect on his face, so I pushed closer and complemented with a little bit of my own light, a very appropriate photograph in the mood that I was convinced he enjoyed and expressed himself best – a menacing character.[53]

*Karsh was part of the American experiment with the character-altering effects of film noir lighting, a skill set developed in the 1940s by both motion picture and still photographers; but light, as crucial as it is to cinema and photography, is seldom dwelt upon at length by critics. They concentrate on the object or the person, or they direct their attention to the plot or the character an actor portrays. This becomes their point of departure for positing their ideas for the primary reason for which the work of art exists and has value. The poet Donald Hall reminds us that critics and professors teach and write about ideas rather than poems, which leaves idealess poems off the agenda. He observes that Keats, in "To Autumn," writes a poem "almost immaculate of ideas." Its value he claims is its statement by shape.[54] So, too, we experience this photograph as a work shaped primarily by the light of a character already known to be menacing. Just re-playing a role in our minds adds no further meaning. If the image has any worth, it must be sought elsewhere. In this residual mystery, this appearance-and-reality puzzle, we are left to face our inability to express our feelings in words, and we go off in search of ideas and meanings to attach to the image that have little to do with the way it came into being, which it seems in this case was over crackers and cheese.*

Peter Lorre · February 3, 1946

*Actor*

There is a barrier where they always think of their favorite role rather than try-
ing to be themselves. I suppose all of their life is of contemporary interest . . .
because they move from one role to another.[55]

> *One may guess which role Humphrey Bogart assumed for his sitting for Karsh: Sam*
> *Spade in* The Maltese Falcon, *Rick Blaine in* Casablanca, *or Philip Marlowe in* The
> Big Sleep. *They were becoming one and the same in the new world of film noir cin-*
> *ema. The tough hero with undertones of contempt and vulnerability was a change*
> *from roles Bogart had as a novice on Broadway. In New York, Bogart was cast as an*
> *out-and-out gangster in 1935 in* The Petrified Forest. *Part of the unknown actor's*
> *appeal was that he looked like John Dillinger, the legendary Chicago bank robber.*
> *After several years in gangster roles in Hollywood, Bogart flipped sides when his*
> *drinking buddy John Huston cast him as a private detective in* The Maltese Falcon.
> *Huston's directorial debut was a hit. Bogart needed to turn but a few degrees to play*
> *flawed, cynical detectives who still retained a few remnants of noble ideals. Although*
> *Karsh intended to capture Bogart's private character, he was equally fascinated at*
> *the time with the new kind of dramatic lighting he was creating for his monsters and*
> *menacing characters. The photographer gave viewers the mood they expected to see,*
> *which in turn pleased the editors of* Life *magazine, who had commissioned the ses-*
> *sion. Perhaps it wasn't the lighting style, and Bogart's demeanor and face had to do*
> *with his casting. "There must be something in my tone of voice, or this arrogant face*
> *– something that antagonizes everybody. Nobody likes me on sight. I suppose that's*
> *why I'm cast as the heavy."[55] Despite Bogart's screen persona and Karsh's uncanny*
> *illumination, if you look past these trappings to the actor's eyes, you glimpse a*
> *thoughtful, sensitive man. That is the key to revealing Karsh's first instinct when fac-*
> *ing subjects who can morph from one role to another: first get the eyes right, then*
> *see what they will relinquish.*

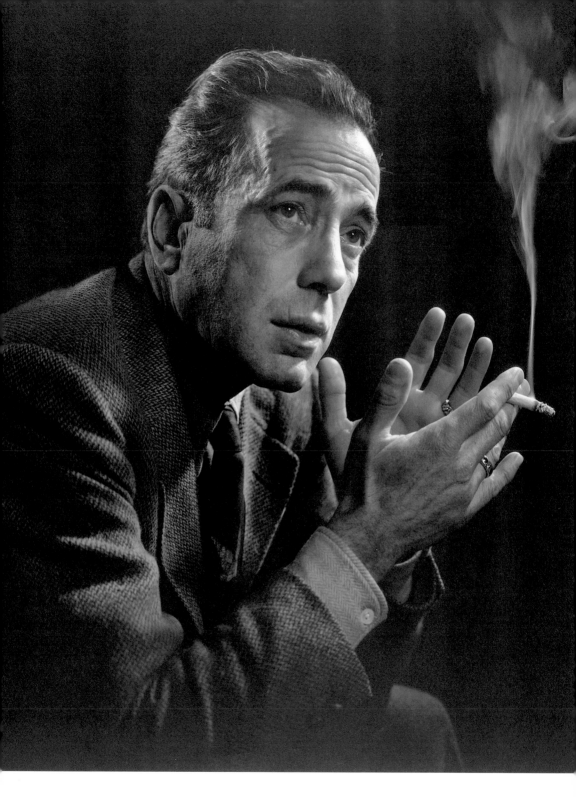

HUMPHREY BOGART · 1946

*Actor*

Ingrid Bergman was a special person, of course. She had enough turmoil in her life to be human, very human, indeed. So much so that the producer of *Joan of Arc* asked me to please submit this photograph for their guidance. And ultimately they gave it to Ingrid for her private collection. She wrote me a charming note, and she finished her letter saying, "You have done more than justice to your sincere Ingrid." [57]

The public turmoil in Ingrid Bergman's life was her extramarital affair with the Italian film director Roberto Rossellini. The resulting pregnancy was a scandal that spread as far as the floor of the United States Senate where she was denounced. But that was four years after Karsh's 1946 portrait. Karsh's reminiscence may also refer to Bergman's youth. At the age of three, her mother died. At thirteen, she lost her father. The aunt to whom she was sent died six months after her arrival. Through it, Bergman kept alive her dream of becoming an actress, and she retained what the producer David O. Selznick discovered: "... her natural sweetness and consideration [will] become something of a legend ... and is completely in keeping with the fresh and pure personality and appearance which caused me to sign her...."[58] Karsh shows Bergman from her preferred left side, the side that viewers saw in her love scenes. She posed without the synthetic-looking make-up to which other Hollywood actresses were partial. This "fresh and pure" portrait that he sent to a production team in 1948 may have influenced their decision to cast Bergman in the role of Joan of Arc. Perhaps the actress thought so and was especially grateful because the role led to her fourth Academy Award nomination for Best Actress. Fortunately, Hollywood can be a forgiving place as long as offenders have box-office success. Bergman earned her second Oscar in 1957, and returned to the prestigious award ceremony a year later as a presenter, receiving a standing ovation as soon as she appeared on the stage. All was forgiven, and her better side was celebrated for the remainder of her life.

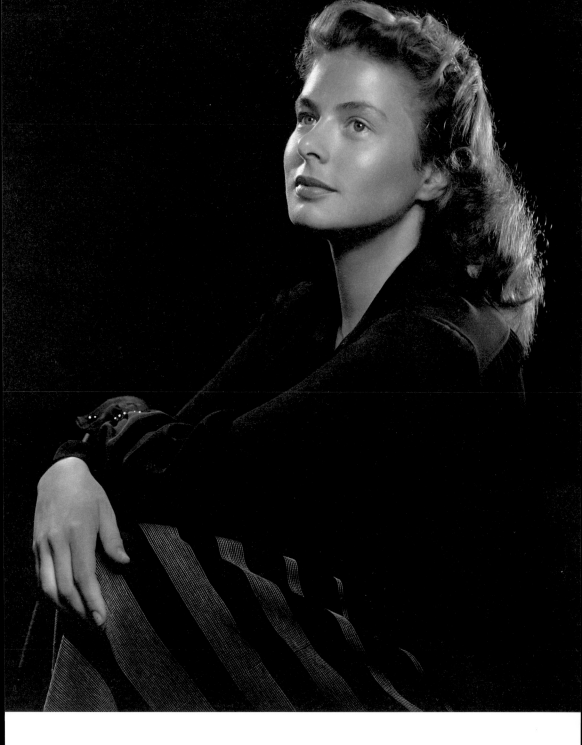

INGRID BERGMAN  ·  February 24, 1946

*Actress*

I photographed Elizabeth Taylor at the age of fourteen soon after her cele-
brated fame in *National Velvet*. I photographed her at the home of her father
and mother. There were squirrels around and chipmunks and dogs. And she
was, of course, a joy to look at because she was natural with a beautiful little
voice. As we were working, I noticed a cat around. I said, "Come in, come in,
come in Michael." And the cat joined [us] and was suddenly in the arms of
Elizabeth Taylor. The next day I happen to be on the grounds of MGM and
she was being driven. And she said, "Mr. Karsh, Mr. Karsh, look and see who's
in the back: Michael Wild Karsh. It was the first time I met the cat, yesterday,
when you called, and I have adopted [it] since."[59]

*Elizabeth Taylor convinced her parents to allow her to wear something more mature
than girlish frills and ruffles for part of the sitting. The elegant wardrobe and Karsh's
darker tonalities make the starlet look older than her age. Even though her skin was
nearly perfect, Karsh used the softer light that he used with older actresses. He was
not experimenting with harsh spotlights scraping across foreheads as he used on
Humphrey Bogart or the multiple-source lights he used on Boris Karloff. And even
though in this portrait there are highlights from behind, the overall effect harkens
back to the natural lighting he had learned during his apprenticeship in Boston in
John Garo's daylight studio using only reflectors and shades. Although Karsh enjoyed
the highly interactive process of photographing movie stars and the extra time they
were willing to give to him, he found it difficult to keep actors from acting when a
camera was present. He wanted to photograph them as people rather than the screen
personas that were their professional identities and their livelihoods. Few photogra-
phers had or would succeed in this quest of unmasking Hollywood idols in a portrait
studio, for it seems even a fourteen-year-old girl could mature a full ten years simply
if she wanted to.*

ELIZABETH TAYLOR · February 14, 1946

*Actress*

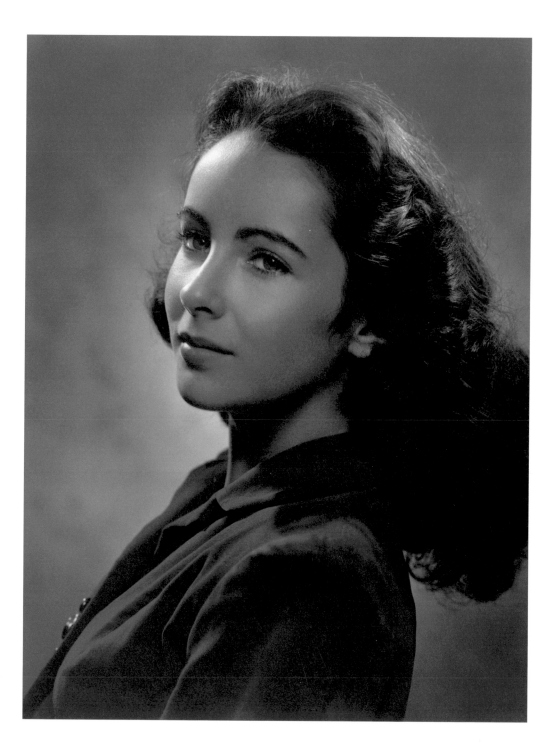

She was the young darling of America, everybody's little girl, sometimes bratty, but always loveable, kid sister. She could cry on demand of the director, and contentedly ate chocolate ice cream cones, her face wreathed in smiles, after finishing her most tearful scenes.[60]

*Margaret O'Brien might have been expected to become an entertainer. Her father was a circus performer and her mother a flamenco dancer. The bratty, but loveable, kid sister of Karsh's recollection comes from O'Brien's role as Tootie in* Meet Me in St. Louis, *which earned her a Juvenile Academy Award in 1944. "I was a pretty nice little girl and didn't get into much trouble as a kid. I was quiet. But as Tootie I was able to say and do all the things that maybe I would not have done myself."[61] O'Brien's face was well known from her films, and so were her Tootie pigtails. The braids were such an important part of the young actress's signature look that when Madame Alexander issued the Margaret O'Brien doll of 1946/47, it came with the hair already formed into pigtails. Before the time of his Hollywood commissions, Karsh had had plenty of experience photographing children. From the founding of his Ottawa studio in 1932, he had been constantly occupied with making photographs of family groups and their individual members. Children responded well to him because he would give them his complete and undivided attention. He met them on their terms, gladly getting down on the floor, dancing, or just chatting about what was on their minds. The session with O'Brien was obviously fun for both of them. It is impossible to tell which one of the playful participants came up with the mischievous motif, the photographer experimenting with poses or the actress clowning around. The spontaneity and skylarking were a welcome break from the serious business of older actors and actresses guarding their well-rehearsed idol images. In this sitting, all that the young actress had to do was to be herself. That went for the photographer too.*

MARGARET O'BRIEN · 1946

*Actress*

I was playing tennis with a friend at the Beverly Hills Hotel and he was very much part of the Hollywood group, a young lad, and he said, "If you beat me at tennis" – we were playing singles – "I shall reward you with kissing one of the most beautiful women in Hollywood." "Who's that?" "Joan Crawford." Well, obviously I couldn't afford to lose. The promise was fulfilled and honored. I like her very much. I paid her several visits afterwards with the photographs. She liked them very much because not only did she look elegant but she was with her very lively toy white poodle.[62]

> This composition gives Crawford's dog nearly equal billing to its master. They are both poised and radiating glory. The actress seems especially contented, having recently won an Oscar for her leading and title role in Mildred Pierce. The film was Crawford's comeback triumph after a magazine had declared her, Katharine Hepburn, Greta Garbo, and Marlene Dietrich as "box office poison."[63] The stark vertical black and white background was a format debuted by Edward Steichen in Vanity Fair in 1930 in a photograph of Marian Morehouse modeling a black Vionnet dress with a white ermine wrap in the black portion and a floral arrangement occupying the lighter area. Two other portraits from Karsh's session with Crawford demonstrate his range of lighting skills. In one, the actress's face is gracefully revealed, but it still alludes to her harder edged personality. She is seen as grand, perfectly within the role she occupied in Hollywood at the time. In the other, she affects a different persona, as her face is heavily shadowed and inaccessible. The three characters that we see in this set of photographs were only partly created by Karsh's skills as a photographer. They were possible because the actress could change roles and character at will by the minute or by the decade as she had done and would continue to do over the years of her long career.

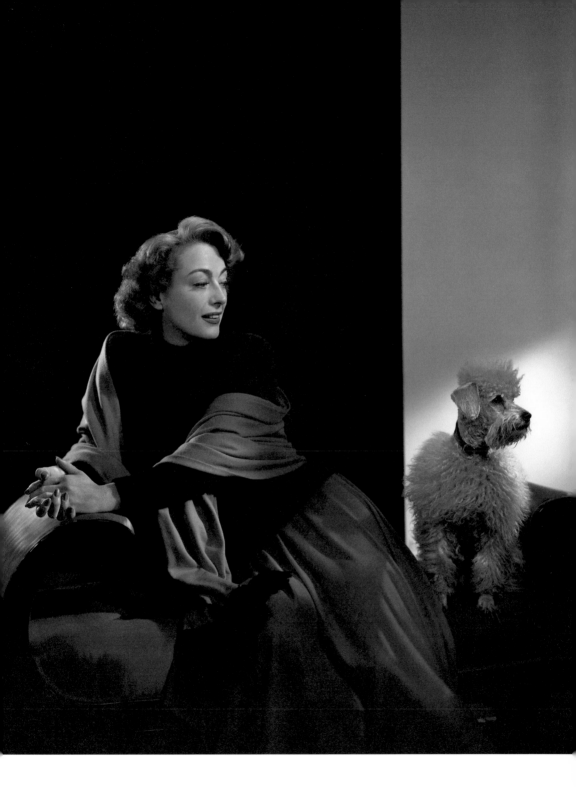

JOAN CRAWFORD · December 2, 1948

*Actress*

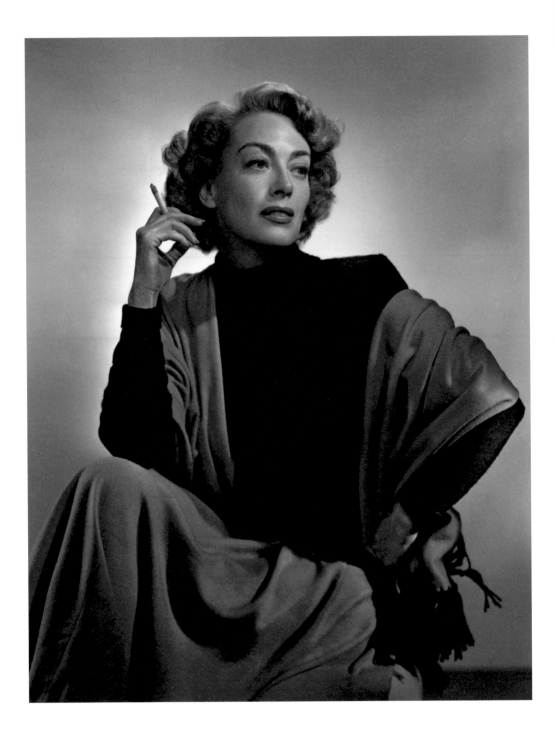

JOAN CRAWFORD · December 2, 1948

*Actress*

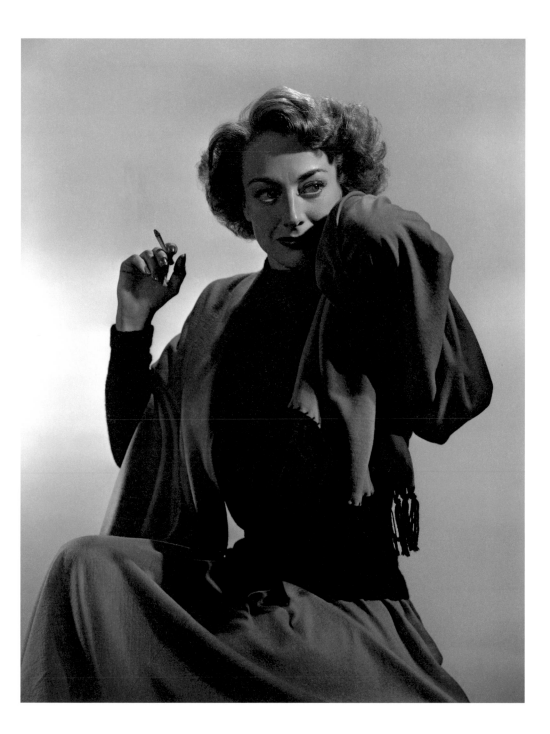

JOAN CRAWFORD · December 2, 1948

*Actress*

Among the tasks that life as a photographer had set me, a portrait of Albert Einstein had always seemed a "must" – not only because this greatest refugee of our century has been accounted by all the world as the [most] outstanding scientist since Newton, but because his face, in all its rough grandeur, invited and challenged the camera. Knowing him to be an accomplished violinist, [I] asked if there were any connection between music and mathematics. "In art," he said, "and in the higher ranges of science, there is a feeling of harmony which underlies all endeavor. There is no true greatness in art or science without that harmony."[64]

G. H. Hardy, the English number theorist, also saw the link between art and mathematics. "The mathematician's patterns, like the painter's or the poet's must be beautiful; the ideas like the colors or the words, must fit together in a harmonious way. Beauty is the first test: there is no permanent place in the world for ugly mathematics."[65] Although Hardy and Einstein were contemporaries at the top of their fields, it was Einstein who was literally the picture of genius. Most photographers wanted to capture the famous, old physicist with his mass of disheveled white hair radiating with brilliance like the sun's corona during an eclipse. Not wanting to duplicate easy symbols, Karsh hoped to reveal something else, something beyond mere intelligence; perhaps he was aiming for wisdom. During the sitting, Karsh asked if Einstein was optimistic about the future of mankind. "No. But if mankind fails to find a harmonious solution then there will be a disaster on a dimension beyond anyone's imagination."[66] Karsh believed he had portrayed the great thinker and crusading pacifist as no one else had, as a man who was both truly great and truly good. The test of that claim should not be the physicist's clasped hands. That was a symbol meaningful to Karsh, a man of faith, and not to the agnostic scientist. The test is in the place it belongs, in a portrait of a man who the photographer felt was beyond hope or despair – in his eyes.

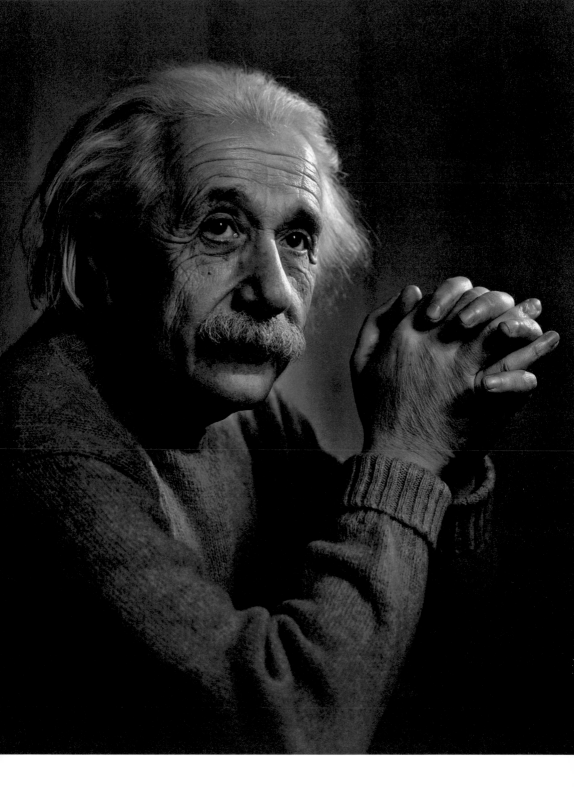

ALBERT EINSTEIN · February 11, 1948

*Theoretical Physicist, Mathematician*

This Johns Hopkins surgeon ... was a splendid example of a physician who cared. He brought a hopeful atmosphere of warmth and reassurance into the sickroom. To a poor woman, apprehensive about the extent of her forthcoming surgery and the size of her bill, he said, "I think I know what you want me to do - as much as necessary and as little as possible." I later learned that the payment Cullen received for her operation was his most cherished fee - a sack of hickory nuts, which the woman's grateful husband placed on his doorstep on Christmas Eve.[67]

*When the sixteen-year-old Yousuf Karsh set foot on Canadian soil, he had dreams of becoming a physician. The uncle who cared for him in Sherbrooke, Ontario was a successful photographer, but not a wealthy man. Karsh needed language skills and years of schooling before he could be considered a student headed toward a medical degree. Years later, when asked if he regretted losing that dream, he said, "Yes, I did. But I saw to it that I gave the opportunity to a brother of mine, and he is a doctor now. But basically, I think I am of equal service to humanity in this respect. . . . Sometimes I find myself in the role of psychologist, sometimes psychiatrist, although I don't take it seriously. But the idea is that I feel I am able to help people while I'm photographing them."[68] Those who worked with the photographer during sessions tell of situations when a famous or powerful sitter confided personal secrets to him. It may be that they had few others on whom they could unburden themselves. It happened over and over again, because Karsh had an ability to gain the complete trust of his sitters, the same way good doctors do. None of the secrets ever left the room, which only enhanced the photographer's reputation for discretion. Knowing this makes one wonder what his sitters said to him, and whether any of the several popes whom Karsh photographed had anything to confess.*

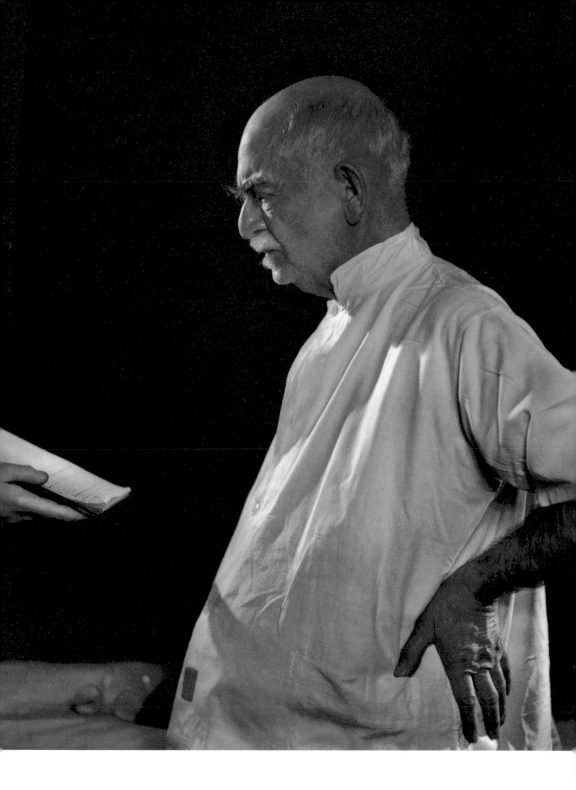

THOMAS S. CULLEN · January 12, 1947

*Surgeon*

I had gone to see Martha Graham, and I photographed her the following day, and she was wonderful. I go to her home and this place [has a] very, very low ceiling, so that no dancer [would] have freedom to get up and go through motions. But she is a great artist, therefore she sat down on a stool, which doesn't show, but still her hands are in a great flow of rhythm and harmony and expression. She looks like a mask and that is exactly because the world of dance is a world of make-believe, it's a world of interpretation, of folktale and folklore. And realism doesn't apply to the dance, dreams do.[69]

*The American poet Wallace Stevens expressed something similar to Karsh's sentiment in an idea he jotted down in his notebook: "The final belief is to believe in a fiction, which you know to be a fiction, there being nothing else. The exquisite truth is to know that it is a fiction and that you believe in it willingly."[70] With her eyes closed, her face hovering dramatically above the sinuous gesture of her hands, Martha Graham assumes a role like that of a Kabuki actor in an iconic pose. But it is not a frozen moment, rather one unfolding fluidly, as in a dream. Restricted by space, the dancer still creates a world of her own. Her expression brings us to its edge, making her both distant and immediate. This other state of being for an artist appeared in Stevens's poem "The Idea of Order at Key West" (1934). Substitute the singer in the poem for the dancer seated on her stool, and you have a psychological description of Martha Graham in this photograph: "She was the single artificer of the world / In which she sang. And when she sang, the sea, / Whatever self it had, became the self / that was her song, for she was the maker. Then, we, / As we beheld her striding there alone, / Knew there never was a world for her / Except the one she sang and, singing, made."[71]*

MARTHA GRAHAM · February 13, 1948

*Dancer, Choreographer*

Don Michals: So many of your people have been applauded for their achievements, but of all of them, who would you say had the greatest spirit? Karsh: Helen Keller. And I was fortunate enough as part of my homework to have met and known and photographed Catherine Cornell and Martha Graham. [At a lunch together] they assured me that they would arrange for me to photograph her. But they also prepared me emotionally that as you meet this wonderful woman she will place her fingers on your lips and on the chord of your speech. In essence she photographs you in her mind.[72]

*Everyone who met Helen Keller left impressed. Karsh referred to her as the most sublime woman he had ever photographed. As a photographer sensitive to light, a lover of music, and a storyteller, Karsh must have wondered how such spirit existed within a woman whose sight and hearing were lost in early childhood. Communication with Keller was entirely through her hands, and thus her hands carry more meaning than any others in Karsh's work. It was through her hands that Karsh communicated something special to Keller during the session in her apartment. "One of my early attempts to read English, years ago, was an article in* Reader's Digest *called 'How to Appreciate the Beauties of Sunset.' Now, I shall no longer think of you in terms of sunset but of sunrise."[73] Keller replied, "How I wish that all men would take sunrise as their slogan and leave the shadows of sunset behind them."[74] Keller had left shadows behind her. Karsh knew something about that. One of the most remarkable things about Karsh was that he carried no hatred or ill will for what he had experienced during the horrible years of depravation and murder of family in the Armenian Genocide. His mother taught him that the perpetrators would have ceased their actions if only they truly knew what they were doing. She told him to forgive them for it. This is how Karsh achieved his remarkable ability to look only to what lay ahead. Helen Keller knew something about that as well.*

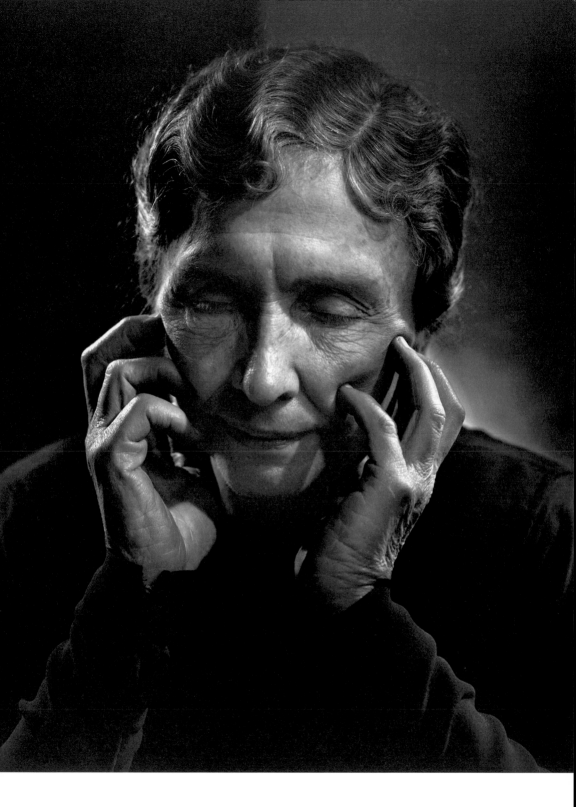

HELEN KELLER · March 8, 1948

*Writer*

When ultimately I went [to photograph] Sibelius, I was carrying so many gifts, from Ralph Vaughan Williams and our Canadian High Commissioner, to London. His welcome was warm and engaging. And we immediately started [working and then used] the gift from the High Commissioner: a magnificent bottle of cognac. So we savored that at 11:00 [A.M.] with some coffee and cake. The next day we worked. But only [later] did I present him with mementoes and gifts because there was no [time] with the enthusiastic reception with his family around him. It was more effective to give him the gifts the following day.[75]

> *Returning to Europe in 1949, Karsh found he was known in England but not on the Continent, which made securing appointments difficult. He needed introductions. In the case of Jean Sibelius, he secured one by chance through Shell Oil Company executives in London, whom he was photographing. An associate in Helsinki was an old friend of the Sibelius family. Suddenly, everything was arranged. Even the reclusive eighty-four-year-old composer cooperated and had a power line run from the road to his house for Karsh's five floodlights and a five-hundred-watt spotlight. "This is my last hope of having a good photograph," Sibelius confessed to Karsh when they met.[76] Despite failing health, the composer was willing to work with the photographer for two days. "The old gentleman's hand was shaking all the time I was with him, and the frailty of old age was apparent in his voice and bearing. But the camera has almost limitless power of selection, and although the signs of age and the ebbing of life were there, it could still capture, in a fleeting second, the noble soul and the immortal music of one of the world's finest composers."[77] Could one perception simply overwhelm another truth? To find out, the pair worked in concert to create a way to cheat physical reality through a visual metaphor that brought to light the vibrant spiritual strength still resident within the dying musician. Happily, Sibelius got his wish, and Karsh his prize portrait.*

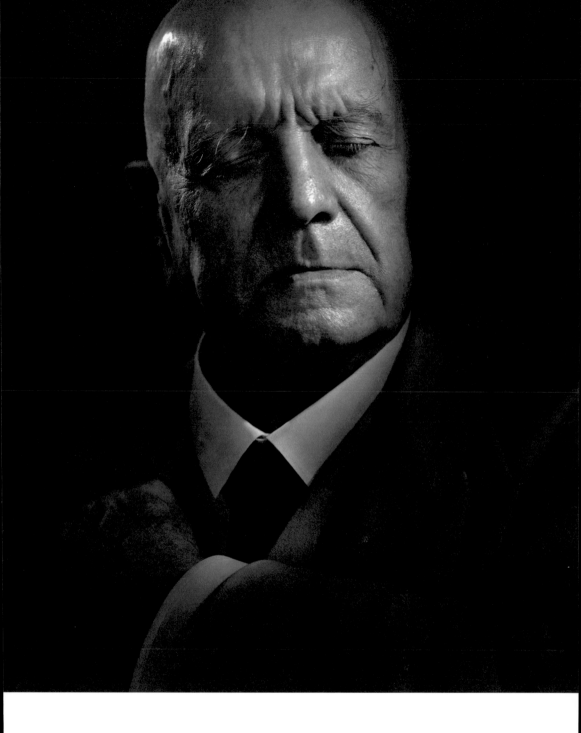

JEAN SIBELIUS · July 30, 1949
*Composer*

François Mauriac was among the eminent French scholars and writers. He proved to be one of the most lively conversationalists. There was no electricity in that building that day. And he lived on the [sixth] floor. We with the heavy equipment [had] to climb up all those floors. Before [it was] too late in the day, soon after lunch, I decided to proceed. There was a long, high French window. I asked the scholar to sit and the housekeeper to bring in a white bed sheet to give us a little detail in the shadow in the face. The main light came from the daylight of the window. As a result, it has given me one of the most satisfying photographs of my photographic career. I like the subtlety of it. There are details in the highlights on this noble profile and subtle shadows in the shade. I was asked years later to photograph him again, which I did. He was so eloquent in his tribute in his appreciation of our first effort.[78]

In a 1953 interview for the Paris Review, Mauriac said: "Every novelist ought to invent his own technique."[79] By the time the photographer met the writer on a gray Parisian day, Karsh owned one of the most unmistakable portrait styles in the history of the medium. That afternoon, Mauriac spoke not of styles but of his intellectual feud with Jean-Paul Sartre, whom the pessimistic novelist considered an even more extreme apostle of negation. In a taped interview almost forty years later Jerry Fielder, Karsh's long-time studio assistant, asked if photographically Karsh had a favorite portrait. He said he had three: Pablo Casals, François Mauriac, and Georgia O'Keeffe. Oddly, none of the three show his signature style. A second portrait of Mauriac that Karsh made in 1965 was also a profile, one again taken by natural window light but at a much greater distance from the writer, who this time is seated in the middle of a bright apartment. The photographer had learned something from his first strenuous and memorable visit: to expect stairs and to come on a sunny day.

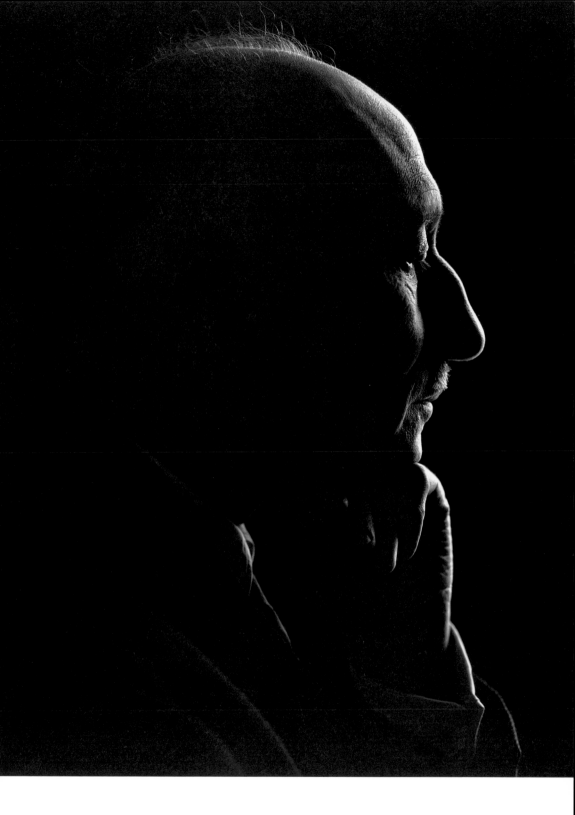

FRANÇOIS MAURIAC · 1949

*Novelist, Member of the Académie Française*

"Happiness," said the most controversial and certainly the most impish of modern philosophers, "comes from pandering to one's self-esteem." I judged from the gleam of mischief in Lord Russell's eye that this was likely to prove a controversial sitting. I was wrong. My subject delights to tilt with intellectual giants, he expresses a profound and almost terrifying pessimism, but is quite amenable before the camera. He distracted me with his dark thoughts when my mind should have been on my work.[80]

*A different portrait that Karsh made of Bertrand Russell shows the philosopher with twinkling eyes, a perceptible smirk, and a puff of smoke from his pipe. Had he been in costume, he could have played a convincing St. Nick. Karsh's lighting in that photograph emphasized the sculptural aspects and wrinkles of a seventy-seven-year-old face. The theme of craggy faces began years before and continued with Boris Karloff, Jean Sibelius, and many faces to come. Karsh's saving grace was his ability to create a psychological study rather than just a tour-de-force of studio pyrotechnics. This portrait is a simple silhouette of a man and his pipe. It may be that the photograph resulted from those chance events that photographers love. Perhaps, the formal sitting had just ended, or perhaps it was about to begin. Nothing in the picture lets us know. Its mystique is reinforced by the sense that Lord Russell with his distinctive profile seems completely alone in the room, as if seen through a window by a voyeur in the fading light of evening. In that same summer, Karsh photographed François Mauriac, also without studio lights. Why is it easier to read Mauriac as a pessimistic thinker? Was it because Russell's pessimism was in his conversation, not his person? And why could the photographer write that the "great pessimist [Russell] was in good form that lovely summer day at Llan Ffestiniog, Wales?"[81] Perhaps Russell answered it himself: it comes from pandering to one's self-esteem, something many sitters felt during a session with the admiring photographer.*

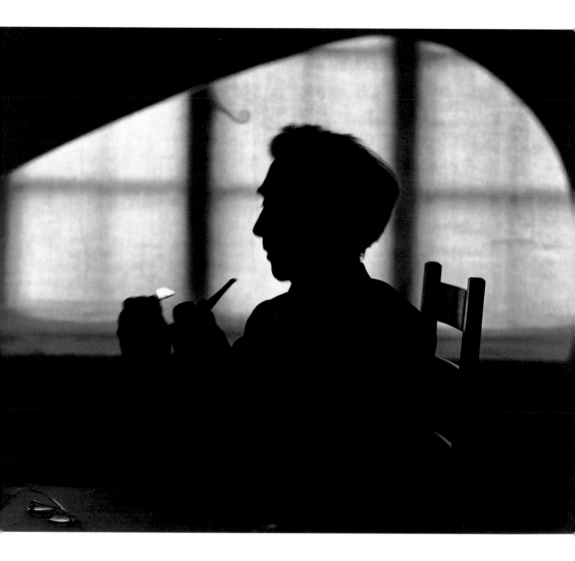

BERTRAND RUSSELL · July 13, 1949

*Philosopher, Mathematician, Social Critic*

[Her] shyness was natural, I'm certain of that. But there was one occasion when she could not help but smile because I reminded the Queen that I had the pleasure of photographing Prince Charles at the age of three. Charles came in from the garden with an elegant little flower in his buttonhole. As I approached him with my little gift, he put his left hand on this toy he was about to receive and with the right hand removed the flower to give it to me. When I said that to Her Majesty as I was photographing her, she looked up and said, "Why, was he really that well brought up?"[82]

Karsh's first portrait of Elizabeth, then the heiress presumptive of the British crown, shows her at the charming age of seventeen. In his second session in 1951, a measure of months from her ascendancy, he produced the requisite regal image. Although he showed her in her office, Karsh's recollection about the later session reveals that her sense of wit and warmth remained a part of her character over the decades he made portraits of her. In the first sitting in 1943, when the outcome of the war was very much in doubt, he captured something other than what the serious military and political leaders had to offer. "Her wholesome charm, good humor, and entire lack of affectation" is what Karsh remembers of her in the text of his first book.[83] The portraits were made on Kodachrome color film, which set the relationships of the tones within the composition because of strict technical requirements of exposure and development by the manufacturer. When translated into black and white, the photograph is in a higher key than the darker style the photographer was used to creating, but the result proved to be entirely appropriate to his subject.

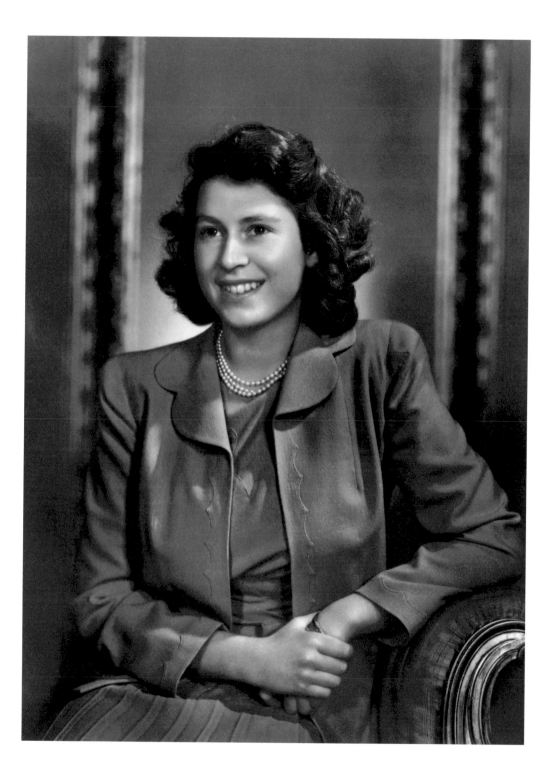

HER ROYAL HIGHNESS PRINCESS ELIZABETH ALEXANDRA MARY OF YORK
November 1943

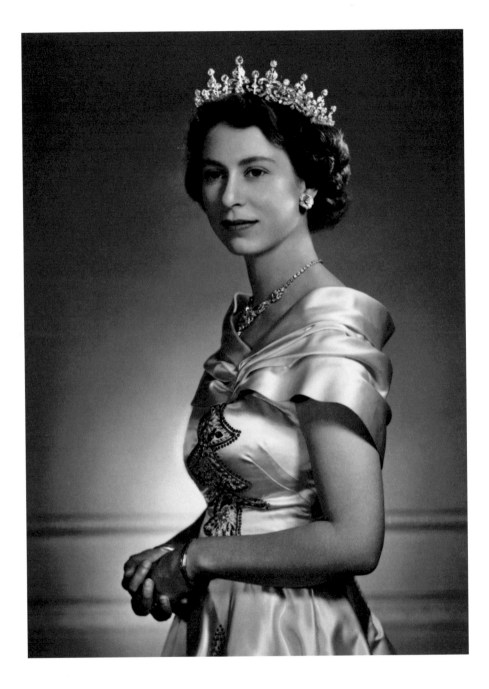

HER ROYAL HIGHNESS PRINCESS ELIZABETH ALEXANDRA MARY OF YORK · July 30, 1951

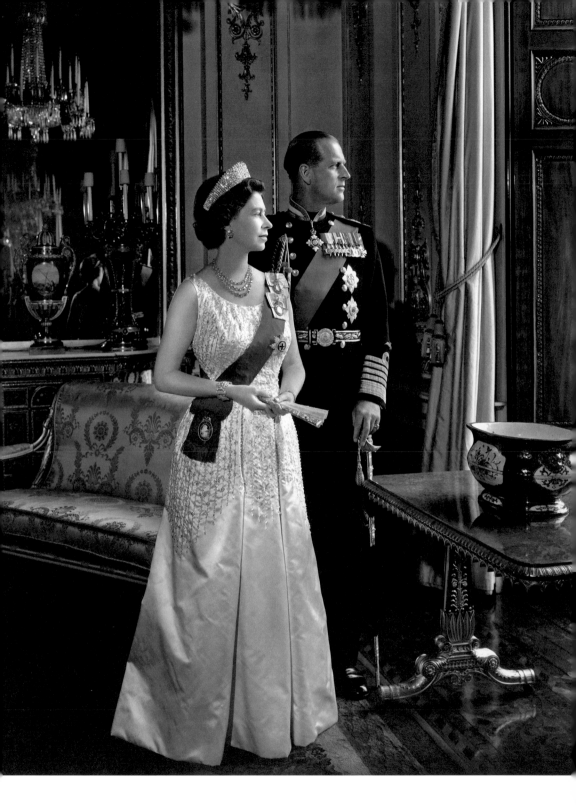

HER ROYAL MAJESTY QUEEN ELIZABETH II AND HIS ROYAL HIGHNESS PRINCE
PHILIP, DUKE OF EDINBURGH · August 2, 1966

I have taken, as you know, the portraits of some of the most celebrated men and women of our time. I tell you these workers are the peers of those men who are better known, I say this, not in disparagement of the great ones, but in humble recognition of the same qualities of greatness in these industrial workers.[84]

*Through portraits of their well-known sitters, a few photographers have attained levels of fame that rival their subjects. They rose from apprentices of a technological craft to celebrity with the growth of mass media publication. Edward Steichen in the 1920s and 1930s was the first to gain worldwide fame. When public prominence came to Karsh in the 1940s and 1950s, he did not abandon his courteous manners, natural humility, or serious work ethic. And wearing a suit and tie, cufflinks, and Fedora hat, he remained a workman. In several commissions to portray subjects on assembly lines, in steel mills, or in spray-painting booths, he devised an innovation to answer the particular challenges he faced. Because space restrictions and light intensity differentials made it impossible to set up the shots he wanted, he first made a foreground portrait with the same standards he employed in the studio and then a second image of the factory environment. In the darkroom, Karsh sandwiched two negatives together in such a seamless way that to this day few viewers have noticed the montage. Ever the photographer drawn to the human countenance, Karsh perfected this method to emphasize the workmens' faces and heroic statures rather than picturing them as cogs in the environment of the industrial production line. It was his way to honor their talents with his.*

GOW CRAPPER, PUTTING TRIM CORD ON REAR WINDOW · 1951

*Plant 4, Ford Motor Company of Canada (Windsor, Ontario)*

TWO STEEL WORKERS · 1950

*(Atlas Steel)*

TERRY TRUSH AND MAURICE LEHOUX
(ED THURMAN AND OMAR LAJEUNESSE IN BACKGROUND) · 1951

*Plant 4, Ford Motor Company of Canada (Windsor, Ontario)*

He came from the Ukraine to Canada, and through his industry and the opportunities of the new world he became wealthy, but he still loved the contact with the land and the feel of the grain.[85]

*In this Regina photograph, Karsh is telling a piece of his own story: how he came to Canada, succeeded, and prospered. By the time he was commissioned by Maclean's magazine in 1952 to make a series of picture essays of Canadian cities, Karsh was so well known that while trying to work on the streets of Vancouver he was surrounded by autograph hunters and newspaper reporters. The two long journeys, visiting sixteen cities, were Karsh's first opportunity to travel the vast country from coast to coast. When the first series of articles was published, the magazine received a significant number of negative responses from citizens who felt they were owed a sanitized, tourist-board view of their metropolises. A conservative member of Parliament went as far as to label the Armenian-born photographer as a "doubtful Canadian."[86] The provincial politician's remark was an unfair and biased insult to a man who, along with the [Canadian] Prime Minister Mackenzie King, was honored at the end of the Second World War in a ceremony bestowing on him an honorary national citizenship award. This incident inspired Karsh to turn the affront into a positive act by joining the Canadian Citizenship Council on Immigration and chairing one of its subcommittees. Karsh weathered the shock of entering the rougher world of photoreportage, a field for which he had skills but not an unflinching passion for exploiting uncomfortable truths. Something about human prejudice may have been at work, since the second series of illustrated articles, less concerned with the racial mixture of the country, resulted in few negative responses.*

PRAIRIE WHEAT FARMER · 1953

*(Regina, Saskatchewan)*

CALGARY STAMPEDE · 1953

HORSES AND FARMER · 1953

*(Charlottetown, Prince Edward Island)*

[Yukio Ozaki] was the man who presented the American nation with the cherry trees. After the war, General MacArthur showed a great deal of interest in him. He was very hard of hearing. I photographed him in one of the suites of the Waldorf-Astoria. And his daughter was so helpful. As I would observe certain things, as I'm [trying] to express myself, I'd tell it to her and she immediately, in a certain voice that he [was] so accustomed to, she whispered the gist of that talk into his ear. It made a very affectionate and unusual photograph, seeing this famous father and his daughter communicating.[87]

*During her husband's tenure as governor of the Philippines, Helen Taft saw cherry trees blooming in Japan. Later, as wife of the President of the United States, she wanted to help beautify the capital with the same kind of trees. Ozaki, the Lord Mayor of Tokyo (1903-1912), heard of the request and sent three thousand trees to the United States in thanks for the help his nation had received during the Russo-Japanese War (1904-05). For several years after the Japanese surrender ended World War II, gestures of good will were exchanged between the former enemies. As one of their contributions, the American Council of Japan brought Ozaki to Washington, D.C. to address both houses of Congress. As a champion of democracy, Ozaki had opposed the rise of militarism in Japan and had been imprisoned there for his beliefs. He spoke on national television in an effort to ameliorate the hostile feelings of Americans toward Japan. Karsh seized the opportunity of including in the composition Ozaki's daughter and translator. This saved the photograph from becoming a static, impenetrable portrait of an old Oriental gentleman. In obscuring Yukika Sohma's face, Karsh did not have to add special spot and flood lights. Karsh saw he did not even need her face to show in order to portray the tender, human relationship between father and daughter, a happy accident for a photographer who actively avoided the many complications of double portraits.*

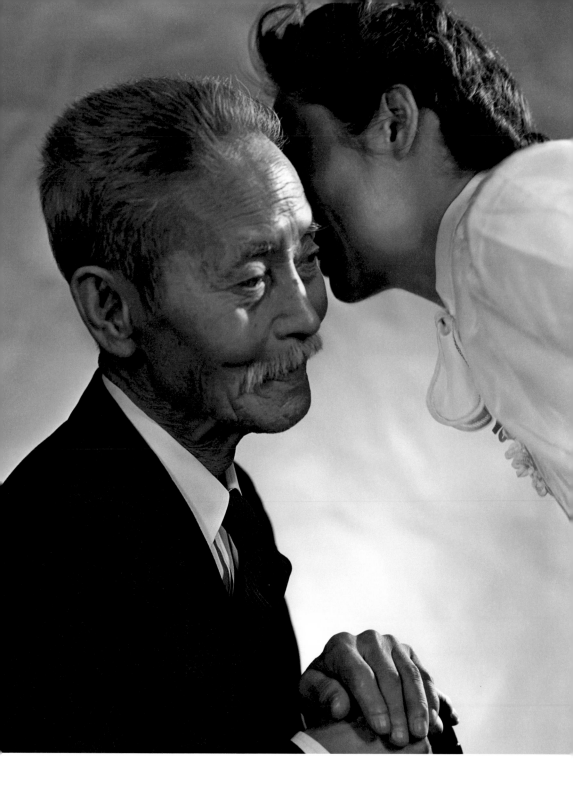

YUKIO OZAKI · May 25, 1950

*Mayor of Tokyo, Member of the Japanese Diet (1890–1953)*

We went to the cathedral first, but it was too baroque. So we went to an old ruined abbey, Abbaye [Saint Michel] de Cuxa. Strangely enough, it had no roof, yet it had beautiful acoustics. As we had gone there especially for this photograph, he was most cooperative and understanding. I said, "Sir, may I be allowed to move around you while you are playing?" He said, "Of course." And suddenly I see this beautiful, devoted figure bending over his cello to play his immortal Bach.[88]

*When Casals and Karsh arrived at the Abbaye Saint Michel de Cuxa, the early Romanesque abbey was being restored. It was a short distance from Prades, France, the town in the Pyrenees that the cellist had adopted as his home, removed from the Spanish Civil War and later from Francisco Franco, Spain's far-right military dictator. The old abbey's bare rooms, resembling prison cells, symbolized the self-imposed exile that Casals had chosen. The unique portrait did not come about because the roof was gone or the abbey was old. The portrait was possible because of Karsh's ability to deal with unpredictable situations by not holding on to preconceived notions as counterbalances. The photographer knew challenges and unique sites offered possibilities. In Cuxa, he discovered that the face was not necessary for a portrait and that the picture could be stronger for its absence. The view of the cellist's back revealed a figure completely encased within a spiritual world. That was the essence of Casals as a musician, and it was the reason he could bring the obscure scores of Bach's cello suites back into the repertoire. As in his earlier portrait of François Mauriac, Karsh demonstrates that, because photography is allied with contingency, photographers must keep every sensibility active at all times. They often need some luck as well, like a working electrical outlet in an old Benedictine abbey.*

PABLO CASALS · July 1, 1954

*Cellist, Composer, Conductor*

CONNIE MARTINSON: What did you do to capture that light in the eyes that is the mischievousness? KARSH: Well, I suppose the light is there already. All you have to do [is] just open a little window to see it.[89]

*Early in 1947, there was revolution and revolt in the streets of Paris. Christian Dior's fashions for women were revolutionary; the revolt was a reaction to it. Dior's taste was not in question, but the extravagance of using twenty yards of fabric for voluptuous, wasp-waisted, full-length dresses coming soon after the deprivation of the war was. The revolt subsided, and by the next April, Janet Flanner reported in* The New Yorker, *"The average Frenchman can now find in the shops nearly everything he wants except the means of paying for it. In midtown Paris shop windows, perfect taste, which is the supreme French luxury, has at last reappeared."[90] Paris was coming back. "The New Look," as Dior's creations were collectively called by Carmel Snow in* Harper's Bazaar, *was embraced. Karsh's portrait of the new leader of Parisian* haute couture *is an enigma. Perhaps the photographer glimpsed this engaging image when Dior shifted out of the light. Perhaps the photographer cast the round-headed, double-chinned designer as an underworld character popular in the movies at the time. Is the finger signaling someone, hushing them, or acting like a gun? No one has a clue; it connects with no known trait of the mild-mannered Dior. Or perhaps the film-noir lighting has something to do with Dior's penchant for superstitions. If we believe the expatriate American writer Gertrude Stein, the fashion world needs no rational explanation: "It was in Paris that the fashions were made, and it is always in the great moments when everything changes that fashions are important, because they make something go up in the air or go down or go around that has nothing to do with anything. Fashion is the real thing in abstraction."[91] Or, one could just say, if fashion has nothing to do with anything, it can last forever.*

CHRISTIAN DIOR · 1954

*Couturier*

When there was a respite of a few minutes waiting or to change films, etcetera, he went back to his writing – and he did all his writing by hand – and with full concentration, as if [there were] nothing else around him. And when he was called to come, he came with equal attention devoted to the photographs. And towards the end of the two days, he wanted to play the organ for us at the church right opposite his home. I thought that was typical of the very man himself, who could have been a great musician, a great organist, fine writer, good man of medicine, and [with] all of this, [he left] to help the lepers in the Congo in French Equatorial Africa, significant of the largess of the nature of this man.[92]

*Karsh had always wanted to photograph "le Grand Docteur" as he called him, but Schweitzer's hospital was in a remote part of west central Africa. When Karsh learned that Schweitzer was returning to Europe in 1954 to give a belated address for his 1952 Nobel Peace Prize, he secured a sitting through the aid of the French writer André Malraux, who he was photographing. Karsh drove to Gunsbach, in the Alsace region of France, where he spent several days making one of his most powerful portraits. As a young immigrant in Canada, Karsh had wanted to be a physician to be of tangible good to his fellow man. This urge stayed with him, and it gripped him in his work as a photographer. If Karsh viewed Schweitzer as a saint, he was not like Marian Anderson. Karsh shows Schweitzer more as a person of intellect than of faith. Schweitzer was not battling racial prejudice arrayed against him but confronting moral questions from a direction of his own privilege. What the photographer shared with the physician was not the power to heal, but an ability to empathize and take on the role of a brother's keeper, as Karsh had done in bringing his younger brothers and parents from their long exile in Syria to Canada.*

ALBERT SCHWEITZER · June 19, 1954

*Physician, Musician, Philosopher, Writer, Humanitarian*

The brilliant composer lives in a tiny kingdom of his own at Aldeburgh in the county of Suffolk, and my driver lost his way to our appointment. Mr. Britten, irritated at my lateness, insisted he must play a regular set of tennis to exercise a lame right arm, and, then, when my camera was set up, leaped into the sea, which comes right up to his house. The plunge cooled him off remarkably and we got on well together after that. [93] His envious dachshund . . . demanded to become part of the picture. Britten swiveled on the piano seat to make room for his canine collaborator, who leaped into the safety of his arms, while yet casting a wary eye on me.[94]

*Benjamin Britten knew that animals on the stage were a risky affair for an opera. In one production of Georges Bizet's* Carmen, *an audience at one performance could not keep their eyes off a dog at the front of the stage. Its head kept switching back and forth to see which way the conductor would throw his baton. In Hamburg, Lauritz Melchior as Siegmund was singing opposite a vocally inadequate Brünnhilde in Richard Wagner's* Die Walküre. *When the dramatic soprano was leading her horse across the stage while singing, the animal relieved itself. During the hush, Melchior turned to the conductor and said, "Everyone is a critic."[95] Animals were also risks for Karsh. If they were in the picture, the photographer expected the animal to play an integral part. In this portrait, after two exposures, the composer's dachshund jumped into the picture. Had it unraveled the composition, the photographer would have courteously paused or ended the session, but the dog changed everything for the better. Its stare in the center of the composition balances the composer's face, hands, and the score of his most recent opera. The dog created a decisive moment caught by the photographer as the white of its eye flashed a warning to the intruder in the room. The dog also brought a genuinely warm smile to the composer's face, one that is not in evidence in the other portraits and was certainly absent at the photographer's late arrival.*

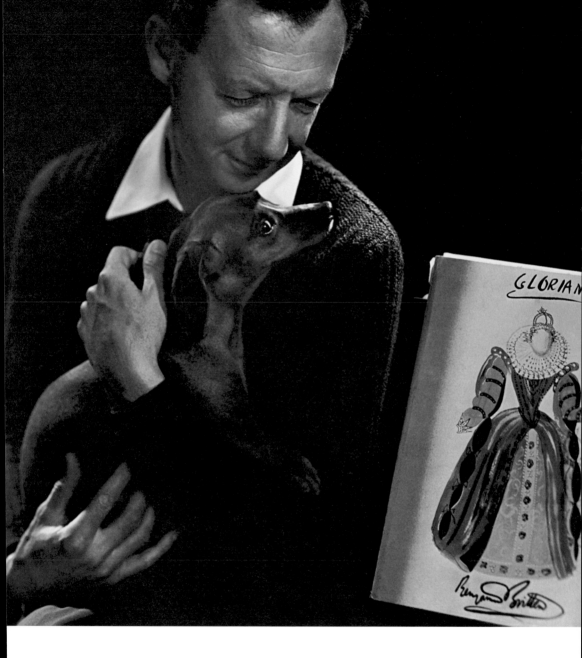

GLORIANA

Benjamin Britten · July 20, 1954

*Composer*

Picasso declared he had seen my work and it interested him greatly. I would have taken this for mere flattery . . . if he had not cited many of my portraits, which evidently he had remembered. During a talk about his work, Picasso argued that the true norm of art must vary with every artist. Each had his own laws. For this reason he objected strenuously to the legend of his artistic anarchy. His work was constructive, not destructive. . . . If people thought differently, that was because they didn't understand what he was trying to do. He was in fact trying to express his vision of reality, and if it differed from other men's visions that was because any reality was real only to one man.[96]

*A portrait of a celebrity can determine how viewers will feel about the subject for decades to follow. Knowing Karsh's perceptive talents, Picasso took two precautions. The first was that he showed up for the session on time. This astonished his friends, who were used to the painter's careless disregard of appointments. As a photographer, Karsh understood the painter's remarks about a singular vision of reality. In photography, unless the medium is used as a tool of scientific measurement, each person matches a perception to a photographic exposure and makes a unique image. Poets have a similar view. Wallace Stevens jotted down a parallel idea in his notebook: "I don't think we should insist that the poet is normal or, for that matter, that anybody is."[97] If the only predictable, consistent, and lasting thing in the universe is nature, it helps explain why photographers are often caught between trying to objectify their immediate environment and trying to imagine the world from various psychological points of view. Although Karsh prepared for his sessions, he never tried to anticipate what would happen and was satisfied only if his portraits registered moments that evolved during the sitting. If this reminds us of the familiar adage that you have only one opportunity to make a first impression, it helps explain why Picasso took the second precaution - again to the astonishment of his friends - of wearing a brand new shirt.*

PABLO PICASSO · July 2, 1954

*Artist*

All his works, large or small, were evidently precious to him – so precious, indeed, that he seemed to regard them almost as personal secrets. He received me graciously and cooperated fully in the making of his portrait, but in conversation he proved to be distressingly reticent. The reticence was deliberate and, I concluded, habitual. This man had been so much abused and so often misrepresented in the press and the pubic mind that he did not intend to discuss his controversial views on architecture, lest he be further misquoted and misunderstood.[98]

*In Le Corbusier, critics find two minds at work: the writer and the architect. As a writer, he was more extreme. His Plan Voisin of 1925 advocated replacing the Right Bank and most of central Paris with a massive grid of cruciform skyscrapers surrounded by flat, parklike spaces. This vision of an economically efficient urban space contained a wealth of innovative ideas that were individually adopted by corporate architects and urban planners decades later. Writing as a theorist on art and urban life, he adopted the name Le Corbusier. It was an alteration of his maternal grandfather's surname, which led to his nickname "Corbu," a truncation of the French word for raven. In Karsh's portrait, we see his ravenlike profile with his trademark eyeglasses perched on his forehead, which affords us a rare glimpse of part of Karsh's lighting arrangement. At the time, Le Corbusier had finished construction on a large urban project that was the core of the new city of Chandigarh, the capital of the Indian province of Punjab. He had also finished the Marseilles Unité d'habitation, a successful apartment building, set in a park for 1,500 residents. The structure integrated balconied, two-story apartments with a shopping area, hotel, and communal roof terrace equipped with a running track and wading pool. Most of Le Corbusier's buildings that were realized are admired, but his utopian ideas of large public housing blocks have often proven to be disasters. This suggests the cautionary parallel that in urban planning, as in life, there may be nothing more detrimental than a strict adherence to an abstract idea.*

LE CORBUSIER (CHARLES-ÉDOUARD JEANNERET) · 1954

*Architect, Urban planner, Theorist, Painter, Furniture designer*

There is a legendary story, and this is truth and not apocryphal. When Frank Lloyd Wright had to appear in court, he was so confident that he said to his lawyer, "Now, please, this time, you must allow me to speak for myself." The court reminded him that he was under oath; he's to speak nothing but the truth so help you God. "Your name, sir." "Frank Lloyd Wright." "Your profession." "An architect, your honor. Correction, your honor, the greatest architect who ever lived." To the delight of everyone, he won that case. And with his cape on his shoulder, he walked a few inches taller, very proud, arm in arm with his lawyer to exit from the courtroom. And his lawyer said, "Wouldn't it [have] been nice if you would let them say you are the greatest architect ever known?" He said, "Look, I was under oath."[99]

*Karsh photographed some of the most spectacular egos of the twentieth century. Fortunately, some of them had fine senses of humor and were amusing eccentrics. George Bernard Shaw and Frank Lloyd Wright were special in this regard. Wright once wrote to the photographer that his habit of giving prints of his 1945 Karsh portrait to colleagues and clients was getting to be an extravagant habit and suggested that Karsh charge him as little as possible for future prints. Karsh was not taken aback. "I told my secretary, there are two people in this world that I want to welcome regardless how unexpected their requests are, namely George Bernard Shaw and Frank Lloyd Wright."[100] In this portrait, Karsh includes the immediate environment of Wright's architecture in the composition. As a photographer he is enchanted by the play between the bright Arizona sunlight and the intricate architectural elements. The face, however, was always another territory for Karsh. Here it receives its own lighting treatment, allowing us to speculate on the personality of the aging genius separate from his environment. As we contemplate the architect within his architecture, we see that his creation preserves the life it was given while the creator is moving on to a different and inevitable end.*

Frank Lloyd Wright · January 30, 1954

*Architect*

We met in his small New York apartment and decided that the portrait should be made in his own environment. . . . I found the master in the scene of his work, surrounded by his typewriter, his manuscript, and his ever present glass of Scotch. . . . The playwright's deceptive ease of manner, his informal speech, and carefree air reminded me of various characters made by his pen – ordinary-looking men hiding an unsuspected fury which invariably erupts on the stage, often in tragedy. . . . As Mr. Williams admitted rather shyly to me, and as he has written in moments of candor, he is a man burning with a sense of life and desperate to communicate it somehow to his fellows. He cannot communicate it freely in conversation because, he says, there is a certain sense of social restraint even among friends meeting face to face; to the great, dark, faceless audience of the theatre he can at last speak freely without any reticence.[101]

*Karsh characterized the mood of this portrait as having a spark of volcanic inner fire.[102] Had Karsh contrived that idea and sought it before the posing began, the resulting photograph would probably not have been a success. As playwrights let actors give life to their scripts, so too photographers let sitters animate their encounters. Even objects play their parts. The lamp at Williams's writing desk that adds a dark, swirling mysterious form would have been impossible to imagine in advance. But there would most certainly have been smoke, since Williams was a heavy smoker. In many of Karsh's portraits in the 1940s and 1950s, we see his subjects smoking. It was then a common habit. Cigarettes helped in the sitting as they gave his subjects something to do with their hands. And with its curious shapes, smoke was highly photogenic under studio lights. In the movies, cigarettes were used to amplify the scripted persona: suspicious characters were confirmed as evil, refined characters grew more sophisticated, and attractive characters acquired sex appeal. And just as if he were in a play or a movie, the cigarette helped Williams become more emphatically what he was: a character with a haunted, self-reflecting soul.*

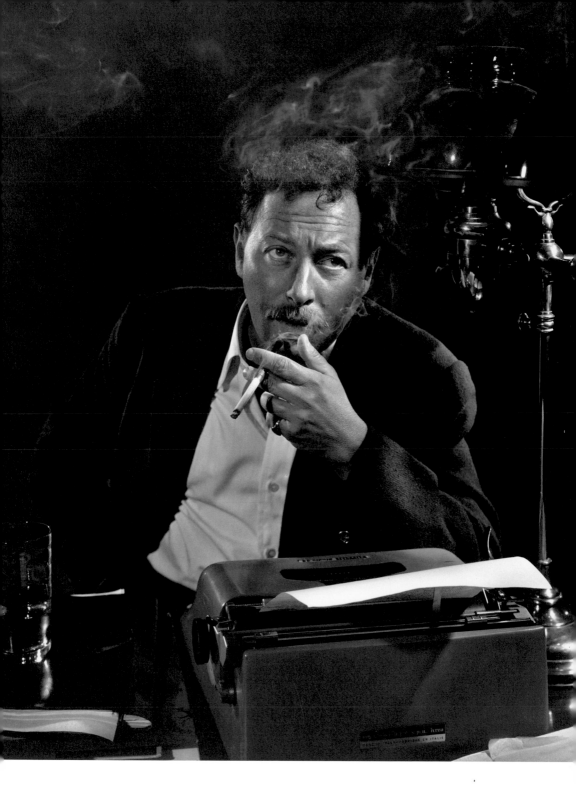

TENNESSEE WILLIAMS · 1956

*Playwright*

[This] is outside of her home, in the entrance, and she tells that she fell in love with this home because of the doorway. So, I sat her there without any other light, just the natural light. It's really almost symbolical of all her career, the skull that is on the wall, the lovely light streaming in and etched over that extraordinary and sensitive profile of hers. [103] It's a serene photograph. She looks calm. And it's different than any of Karsh's work, so that there is still departure.[104]

*"There is still departure." Karsh meant that after nearly a quarter of a century there were new avenues of approach to creating portraits, even in the traditional way he worked. Here, remote from any city, in thin, arid air, sat one of his most admired heroes, a legendary painter still actively working as she approached seventy. The photographer Alfred Stieglitz had made stunning portraits from 1918 to 1937 of O'Keeffe, first as his lover and later as his wife. During the process, O'Keeffe became less of an object for his ideas and more of a commanding, independent woman looking back. She had always been a striking figure with an exquisite profile. Karsh knew all about striking figures and profiles, and, by this time, a lot about accomplished women. What he may have found new was the strong, clear diamond light of the Southwest. In the portal to the painter's house with walls bouncing fill light everywhere, he needed no auxiliary lights, only a camera. As with François Mauriac, he chose a pose that graphically defined the profile with a tracing of light. But this was not gloomy Paris. Another atmosphere prevailed at the Ghost Ranch. Ancient New Mexico is a magical place, a setting that had stunned O'Keeffe when she first saw it in 1929. She absorbed it, and, in her presence and in her home, Karsh saw and felt it her way. The setting filled him with such a new sensation that the veteran photographer completely at a loss for words could describe the unique image only as a "departure."*

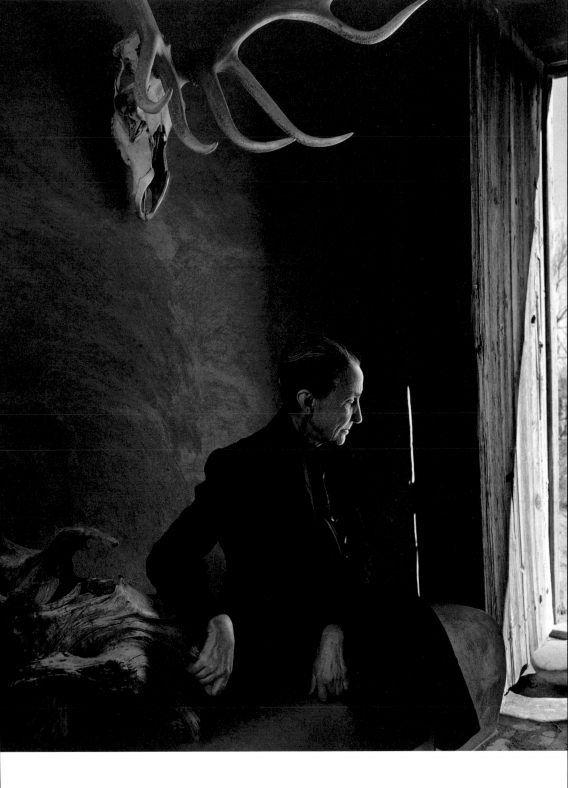

Georgia O'Keeffe · March 18, 1956

*Painter*

I photographed Audrey Hepburn in the Paramount Studios. I had seen her in various movies, and she did not surprise me in this meeting. I had expected to find her rather brittle, extremely sensitive, and always emotionally charged. So she is. Intensity, I suppose, is her particular quality and her particular success. Beauty is combined with an insatiable appetite for life, and for work too. Unlike most movie stars, Miss Hepburn was comfortable with only a line of eyebrow pencil and some lipstick. Her natural beauty requires little assistance from the art of make-up.[105]

*Hepburn and Karsh were both lucky to have survived horrible pasts and then go on to enjoy dream careers and fame. In 1935, Hepburn's Anglo-Irish father abandoned the family. She was six years old and devastated. During the war, she studied ballet in Holland under the name Edda van Heemstra to hide her British identity. But true horrors were ahead. Her uncle and a cousin were executed by the Nazis. During the winter of 1944, her family was reduced to making flour out of tulip bulbs. Malnourishment during the war and her relatively tall five-foot, seven-inch height later prevented her from becoming a prima ballerina, so she turned to acting and worked as a chorus girl. Her break came when the French writer Colette spotted her as the perfect Gigi for the Broadway adaptation of her best-selling novel. Spectacularly, just three years later in 1954, she wore a white, floral Givenchy gown to accept the Academy Award for Best Actress for her first Hollywood film, Roman Holiday. It seemed Hepburn's tragic story had been obliterated with a little eyebrow pencil, a bit of lipstick, and a lot of determined talent. Hepburn spent the last years of her life as a Goodwill Ambassador for UNICEF, helping impoverished children throughout the world. Once, when asked for tips on beauty, Hepburn quoted Sam Levenson: "For attractive lips, speak words of kindness; for a slim figure, share your food with the hungry; and for lovely eyes, seek out the good in people"[106] - nearly a complete list of her best features.*

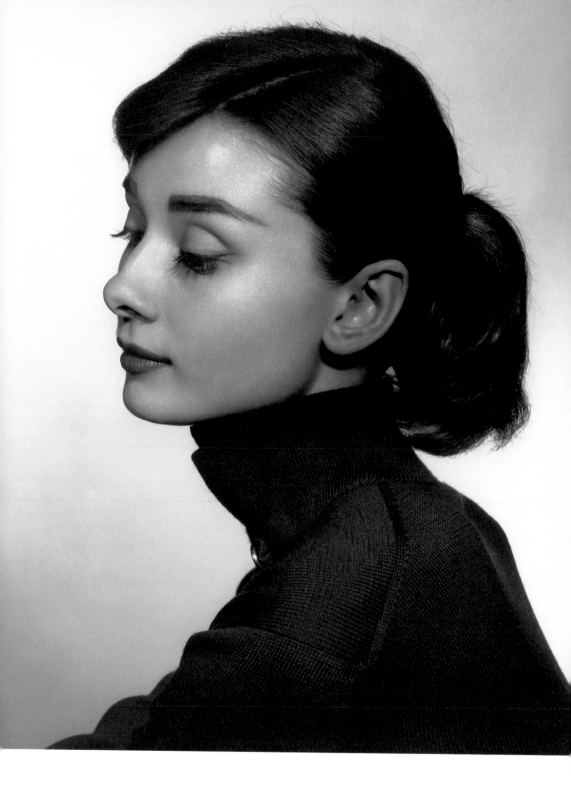

AUDREY HEPBURN · March 23, 1956

*Actress, UNICEF Goodwill Ambassador*

The smorgasbord was already lavishly spread on the table of Anita Ekberg's California home when I arrived. Her natural behavior resembled the love goddesses she portrayed – uninhibited and seductive, and totally without guile. When changing from one gown to another, she ignored the screen her attendant had placed before her. She exuded sexuality; in the garden, as she exuberantly hugged a tree trunk, it became a gesture of utmost sensuality.[107]

When Howard Hughes saw Anita Ekberg, he wanted her to change her nose, teeth, and name – everything else was perfect. She changed nothing. When another film director, Billy Wilder, saw Audrey Hepburn with her elfin figure he said, "This girl, singlehanded, may make bosoms a thing of the past."[108] That was a good Tinseltown one-liner, as scouts, directors, and producers are still falling over themselves in trying to transform voluptuous waitresses and beauty queens into actresses. Ekberg and Hepburn worked together in King Vidor's 1956 War and Peace. Although neither was nominated for an Oscar, Ekberg received a Golden Globe for most promising female newcomer. Throughout the 1950s, the Swedish bombshell was one of the most sought after pin-up models. She kept attention on her physical attributes by orchestrating a wardrobe malfunction with a photographer in the lobby of London's Berkeley Hotel where her dress burst open. Karsh did not resist what Ekberg represented, but instead of seeking something salacious, he translated her curvilinear forms with sensual lighting into something untouchably erotic. This prefigured her memorable role as Marcello Mastroianni's unattainable dream woman in the Federico Fellini film La Dolce Vita. After his first Hollywood experiences in 1946, Karsh knew enough to go with the flow. If he could not prevent actors from acting in front of his camera, there was less likelihood that he could keep this sex siren from oozing sensuality. He had no chance of changing Ekberg into anything else, and if she slipped out of something in front of him, it was never going to be her persona.

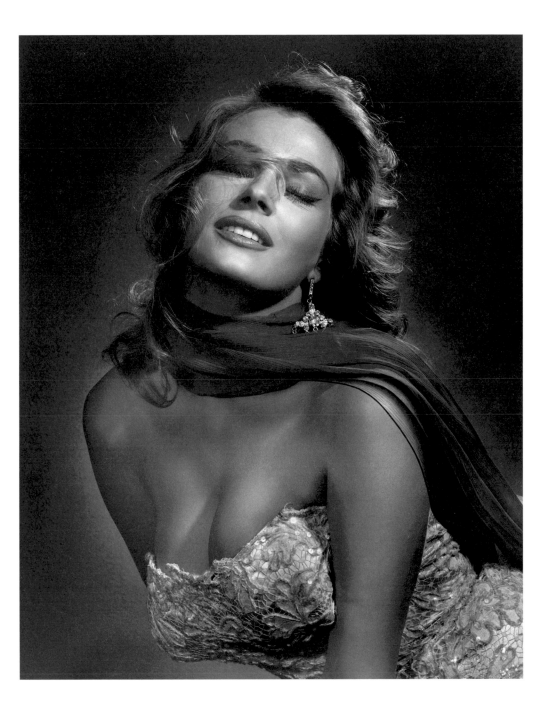

ANITA EKBERG · March 28, 1956

*Actress, Model*

I happened to return to Paris directly from the Vatican photographing Pope John XXIII. And the word had reached her [Brigitte Bardot] that the person that [is] about to photograph you has just come directly from Rome. And with her typical charm and touch of gaiety, she said, "Is it true you have just come from photographing Pope John XXIII?" I said, yes. "Ah," she said, "from the saint to the sinner." We have in our home [in Ottawa] two magnificent sculptures called *L'amour sacré* and *L'amour profane* executed by Louis Legge. But I still don't know [which is which]. And so when Brigitte referred to herself as the sinner, I questioned that completely.[109]

> This photograph of the leading sex symbol of French cinema in the 1950s and 1960s is suggestive, but not overtly lascivious. Its intended purpose was to reveal the actress's personality. If Karsh failed in that regard, there was not likely to have been a complaint from his viewers that the sexual magnetism of his subject proved impossible to disarm. Thirty years after this photograph was made, when looking at early work and coming across one of his nudes, he meditated on why there had not been more. "I suppose to be a photographer of the female figure you have to be born without inhibition. I think something has not supported me because of my upbringing of false modesty. [It] was taboo. I wish it was not the case because I admire greatly the female figure. There have been times when I have been with some friends, two or three women, [who] just for the sheer freedom spend the whole evening talking in the nude completely. There would have been no problem whatsoever to photograph them. If I had children I would teach them not to be so inhibited and if they have the desire to take photographs by all means go ahead and do it."[110] Years later Karsh was still trying to elicit Bardot's other qualities in interviews by insisting that no one should underestimate the intelligence of Bardot because of her beauty. Admirable in his insistence, and a gentleman - as always.

BRIGITTE BARDOT · May 1958

*Actress, Singer*

The animated movie star welcomed me to her New York apartment in blue jeans, with her hair in curlers! Newly engaged to Rainier, the Prince of Monaco, she was in the throes of preparing for her departure for her new life far from the Hollywood sound stages. A few moments later, after running a comb through her hair and quickly changing her clothes, the beautiful woman and future Serene Highness emerged.[111]

*When Larry King interviewed Karsh on CNN Weekend, he asked about Grace Kelly. The aging photographer's face instantly lit up, "Oh, she's beautiful, there's no problem there."[112] Although almost forty years had passed, it seemed easy to remember. He also photographed Kelly and the Prince together, even though he did not like to portray couples. This seems an odd limitation. But to the photographer who had the most acute perception of the topography and the subtle moods of the changing face, it was a supreme complication to get both faces right simultaneously while maintaining a meaningful human connection between them. In attending so thoroughly to the face, everything outside of the face became a surrounding structure for the revelation Karsh brings to its surface. The pose in a Karsh portrait is something that rarely possesses the same fluidity as the face. This is easy for viewers to miss because the result suggests that they were both equally frozen and waiting for the shutter's release. The double portrait that Karsh made of the twenty-six-year-old movie star and her older fiancée was a composition of two overlapping cameo profiles like those seen on ancient coins. In that portrait, the faces themselves are poses, emblems rather than communicators of character or emotion. The same may be said of the single portrait of the future Princess. It is hardly a loss, however. She had one of the most virginally beautiful profiles of all American actresses. As composed and gently regal as Queen Nefertiti, she seems to be gracefully pausing in the continuation of her fairy-tale life. Even without her future title, this photograph alone could have given her the name of Her Serene Highness.*

GRACE KELLY · March 1956

*Actress, Princess of Monaco*

Widowhood and adversity had not yet touched the glamorous young wife of the handsome senator from Massachusetts. Our meeting was at Hammersmith [Farm], her mother's home in Newport. I photographed her against a Coromandel screen that complemented her dark beauty.[113]

*Jacqueline Kennedy, seen here at age twenty-eight, has had one miscarriage and a stillborn child. Yet, in this portrait, she is radiant. After her husband was assassinated, she bore her grief publicly. At the funeral, with her head held up, she was courageous and dignified, which helped millions in mourning throughout the nation. In London the report was that "Jacqueline Kennedy has given the American people one thing they have always lacked: majesty."[114] That was 1963. Here, before becoming First Lady, she abounds in less regal qualities: sensuality and a playful mystique. Three years after this sitting, as the wife of a newly elected president, she began winning the hearts of her country. She created a desire to wear three-string pearl necklaces and pillbox hats. She restored the White House to its proper elegance. She was the toast of Paris where the crowds shouted "Vive Jacqui." With her French heritage and fluency in the language, she was such a hit that the President said as a way of introduction at his press conference, "I am the man who accompanied Jacqueline Kennedy to Paris - and I've enjoyed it."[111] In 1978, Theodore H. White described the Kennedy years as "a magic moment in American history, when gallant men danced with beautiful women, when great deeds were done, when artists, writers and poets met at the White House and the barbarians beyond the walls were held back."[112] In this portrait, the loss of yet another child and the assassination were still in the future. Standing in front of her mother's lacquered Chinese screen with no threats in view, the Senator's wife poses with decorous ease, and in her face we see the Camelot moment that Karsh divined there in the dark eyes of Jacqueline Lee Bouvier Kennedy.*

JACQUELINE KENNEDY · June 12, 1957

*First Lady of the United States (1961-1963)*

John F. Kennedy. The first time I photographed him was with Jackie. And I happened to pass by the Sherry-Netherland. The Senator was having a cocktail with his lady. As she saw me through the window, she ran after me and said, "Oh, Mr. Karsh, tell me, tell me, how are the photographs?" Those were the days free and full of hope and vision.[117]

*Less than four months after the assassination of her husband, Jacqueline Kennedy taped an eight and a half hour interview with Arthur M. Schlessinger, Jr., the president's special assistant, historian, and family friend. It focused on the president because Mrs. Kennedy's role was seen then as a young woman raising small children and being a comfort to her husband. She felt she was in a satisfying marriage, though she characterized it as being "terribly Victorian."[118] "I think a woman always adapts, and especially if you're very young when you get married and, you know, are unformed, you really become the kind of wife you can see that your husband wants. . . . How could I have any political opinions, you know? His were going to be the best. . . ."[119] Since the tragic day in Dallas on November 23, 1963, Jacqueline Kennedy has grown to be as much or even more of a cultural symbol of American society than her husband, and it now seems that the taped interview should have been more about her. But that was the way it was in 1964. Karsh's portrait has aged well because it was both accurate and prophetic. The shadow cast over Jacqueline's eye makes John prominent, commanding a position above her. He stares off as if there were a noble goal to acknowledge and serve. She appears subservient. We sense her love and devotion to him, her grace and caring. Knowing how history evolved, we are not shocked by the Jacqueline in this portrait, which does not hint at her unvarnished opinions of personalities expressed in the tapes. We can see, however, that she has a vision of her own that is not oblique. It is faithful, uninflected, and goes straight to the heart.*

**JOHN F. AND JACQUELINE KENNEDY** · June 12, 1957

*Senator, President of the United States (1961-1963) and First Lady*

[Hemingway is] an adventurous man, a man of great ability in writing. He's loved for the safari in Africa, his courage in the bull ring, yet he was very shy. In retrospect, I feel that this was after [a] second major airplane crash in Africa. When I photographed him, his back was in agony. He could not walk comfortably. And consequently, the shyness he exhibited – I had to work with him alone, asking Mary, his wife, to leave the room [and] my assistant – was merely that the giant of Hemingway's caliber did not wish to exhibit any experience of agony and physical pain. And this was where my experience was reinforced that he was the shyest man I have ever photographed.[120]

*This portrait of Hemingway, dressed in a sweater suitable for chilly days, was taken in the writer's villa in tropical Cuba. There are other contradictions in the picture. One critic wrote that there is nothing in this photograph that teaches us about Hemingway as a writer or as a man. Is it just a big blank face? If so, perhaps it is because we have left the work of the photographer unfinished. Once we learn that Hemingway did not want to reveal his pain, the portrait becomes magnificently stoic. In this moment of equilibrium, free of dramatic flair, viewers can fit facts about the author into the accommodating receptacle of his countenance. One imagines his injuries from driving ambulances in the First World War or the recent lacerations and burns of the airplane crash left their mark both physically and psychologically. Four marriages, decades of heavy drinking, the exhilaration of the blood sports of bullfighting and hunting may be registered there as well. His eyes do not look inward in self-pity but calmly out onto the world from a wealth of experience. And in this unaffected moment of repose, we can empathize with the writer as a wounded survivor or honor him as an impassive, self-assured hero. Karsh's portrait allows for these opposite interpretations. No longer blank, Hemingway's face becomes one rich in the textures of our imagination, which leads us inexorably on to our own self-reflection.*

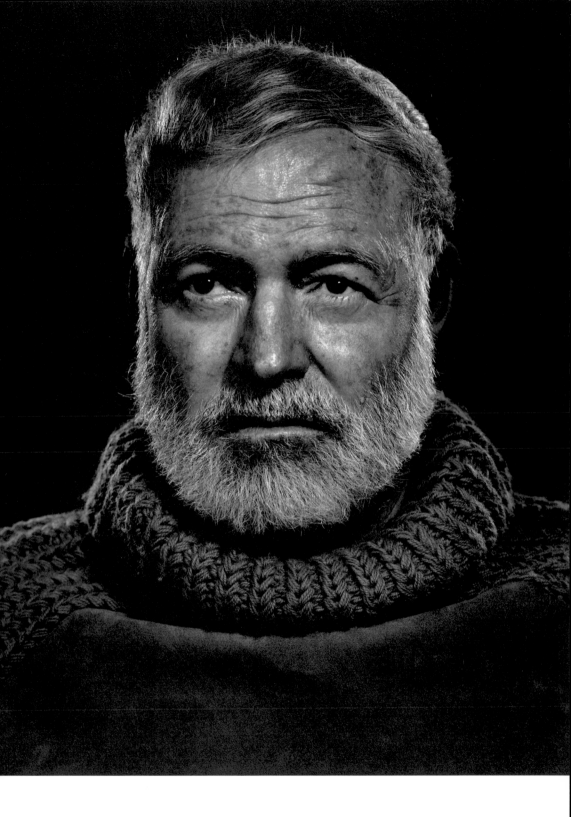

ERNEST HEMINGWAY · March 15, 1957

*Novelist*

Mr. Copland's writings about music have an ease and charm which make even the most abstruse musical question accessible and interesting to the layman. Indeed, the problem of communication between composer and listener has greatly concerned him. He has warned composers that "isolation breeds an ingrown quality, an overrefinement, a too great complexity both of technique and of sentiment." He reminded listeners that "music can only be really alive when there are listeners who are really alive. In other words, art and the life of art must mean something, in the deepest sense, to the everyday citizen."[121]

*Music is the most abstract of all the arts. When over-refined, it too easily separates itself from its most accessible forms found in dance, hymn, and folk songs. Like mathematics, its abstractness contributes to a conceptual evolution that often sets it ahead of its time. Franz Liszt's late piano studies in the 1880s anticipating "atonal" music attracted no audience or concertizing pianists until they were enthusiastically revived in the 1950s. Here we have a different case. Copland's 1944 music for Appalachian Spring, commissioned by Martha Graham for her ballet, was not abstruse as it was scored in familiar American idioms. Copland was a man to whom Karsh could relate completely. Starting from accessible traditions in portraiture, the photographer found his own style through innovative lighting techniques, which were not so avant-garde as to obliterate the personality of the subject. Seeking the good qualities in his subjects allowed the photographer to better communicate with everyday citizens. Something else links the photographer and the composer. Included in the ballet is the innocent Shaker tune and dance, "Simple Gifts": "'Tis a gift to be simple, 'tis a gift to be free / 'Tis a gift to come down where we ought to be, / And when we find ourselves in the place just right, / 'Twill be in the valley of love and delight." It is the perfect musical accompaniment to Karsh's career in which, at the core of every image, one senses a quest not for something to become more convoluted or extravagant, but simply for something to come round right.*

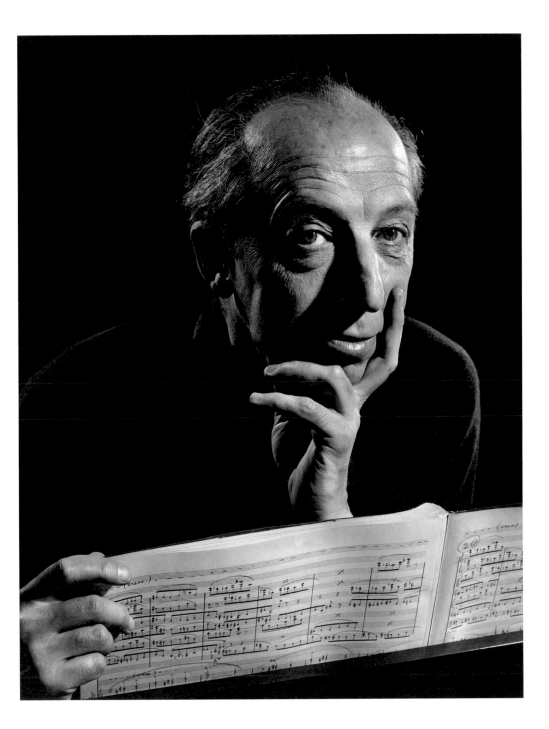

AARON COPLAND · Spring 1956

*Composer*

The apartment of Georges Enesco in Paris was less than modest. It was poverty itself. Yet it contained certain riches and an extraordinary musician who sat amid a clutter of relics and mementoes recalling for him, no doubt, the happier days of the past. I found that he was so badly crippled by arthritis that he moved as little as possible. His desk was placed so he could turn from it to his piano without rising from his chair. He looked frail, old, and exhausted, but at times I caught in his eyes a sparkle, which seemed to illuminate his whole face with intense kindliness and unshakable courage.[122]

*Obstacles are what artists see as opportunities. Cramped Parisian apartments always challenged Karsh. But for Georges Enesco, a tight workspace defined the composer. His hands and arms could reach everything he needed. They also draw us back to his face, and to the blood vessel highlighted on his forehead transforming it into a symbol of the origin of the pulse that surges back and forth between the mind, represented by the score, and the music, represented by the piano keys. The generous floor space Karsh encountered at Norman Rockwell's studio in Stockbridge, Massachusetts presented a different opportunity. While Karsh toiled to tame the large space displaying the artist's work, Rockwell teased him by making more, tossing sketches of Karsh on the floor. Karsh encountered another challenge when he faced the wall of negative white space in Lenore Tawney's studio in New York City. The space was like the white seamless backdrops that Irving Penn and Richard Avedon employed for their magazine portraits and fashion shoots. Using the wall the way an art director fills a page, Karsh turned a work of loose, open warp with curving tide lines of weft into a column of positive space. He avoided casting shadows onto the blank rectangle to keep it depthless and immaterial, which allowed the hovering work to weave the composition together.*

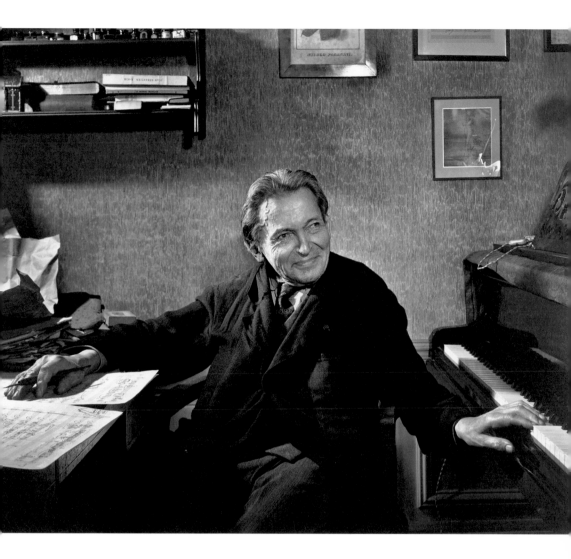

GEORGES ENESCO · June 4, 1954

*Composer*

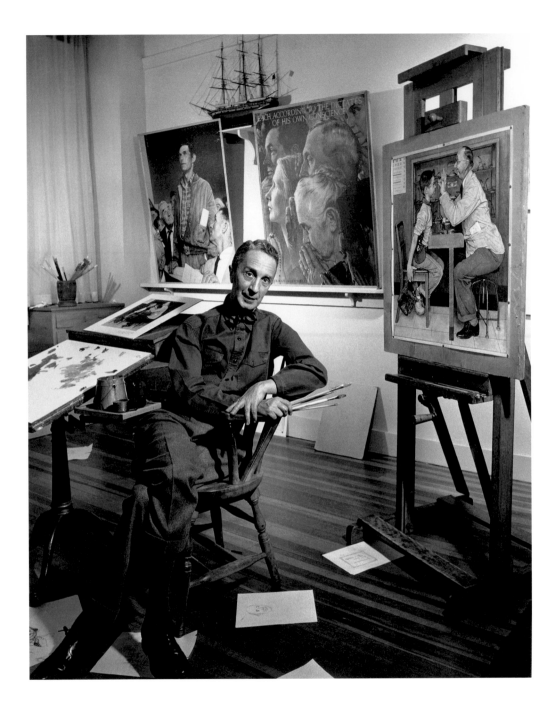

NORMAN ROCKWELL · February 12, 1958

*Painter, Illustrator*

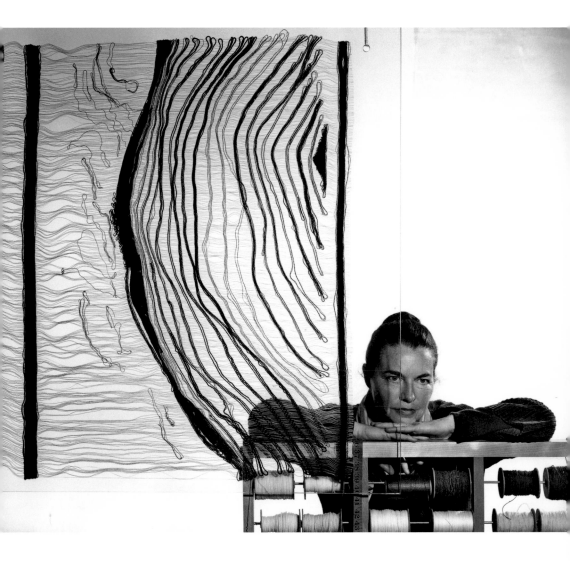

LENORE TAWNEY · November 14, 1959

*Fiber artist*

As I saw Khrushchev walking from his home toward where foreigners are received, I said to myself, "This figure would look more impressive if we had a very big fur coat." I had made my desire known . . . and the answer [from Mrs. Khrushchev] was definitely no, it was April and there [was] no fur coat available. So after working, I switched the light off and I addressed myself to the Chairman of the USSR. I said, "Mr. Khrushchev, I would like the biggest fur coat in Russia possible to photograph you in." And to my delight, he gave the go-ahead signal and within half an hour after that a big fur coat was produced. And the moment [Mrs. Khrushchev] saw this diminutive fellow carrying this coat on his arm she said, "Oh, that fur coat. That fur coat was reserved for Prime Minister Macmillan of England to go with my husband tobogganing so in case the Prime Minister falls, he will not hurt himself."[123]

*Karsh's invitation to visit Russia came six months after the Cuban missile crisis between the United States and the Soviet Union ended. Although the Cold War between the superpowers continued, the USSR was open to easing tensions. The Kremlin invited Karsh to make a series of portraits of dancers, academicians, and political leaders. Karsh was an ideal choice because his portraits did not take political sides, but rather tried to show a human aspect of each sitter. Khrushchev's biographer William J. Thomson observed that "however he came across, he was more human than his predecessor or even than most of his foreign counterparts, and for much of the world that was enough to make the USSR seem less mysterious or menacing."[124] Still, Khrushchev was the face of the West's enemy. The photographer knew that Khrushchev's short, rotund stature and circular face would be improved by a massive fur coat symbolic of the Russian winter. Dressing up in an out-of-season costume was a whimsical idea for which the powerful Chairman was game. And sure enough, a smiling, less threatening Chairman ready for an afternoon of tobogganing was the result.*

NIKITA SERGEYEVICH KHRUSHCHEV · April 28, 1963

*Chairman of the Council of Ministers of the USSR (1958-1964)*

[When the Canadian Governor General Jeanne Sauvé] visited former Prime Minister Trudeau at his home, one of [his] boys was resting, lying down. "Get up, get up," Mr. Trudeau told his son, "and give Madame *un grand baiser* (a great big kiss)." Oh, the boy didn't care one way or the other. For a boy to get up and give a kiss to Her Lady[ship] that's unheard of as far as he was concerned. Anyway, when they had completed their visit, Madame Sauvé in her best manner bends down, wearing a scarf, to kiss the forehead of this child lying down. And now was the boy's chance to redeem himself. [But he just] took the end of that scarf and kissed it.[125]

*Trudeau was an unusual man for a politician. Married at fifty-two to a woman thirty years his junior, their divorce in 1984 left him with their three sons. Before his surprise marriage, the progressive prime minister had been painted by the media as a playboy. It was an inaccurate portrait as he was a workaholic, devoting most of his time to his civic duties. But no matter who raised the three boys, a new era for children had been established. It consisted of a separate economy, music scene, and social habits, and a disdain for their parents' culture. This portrait of the newly elected prime minister was taken long before children came into his life. He is dressed in a black leather jacket and is the personification of a dashing bachelor of intense focus and virility. In a 1986 documentary film, the director Harry Rasky mused, "I wonder how you begin to capture the complexity of our former Prime Minister." Karsh responded, "I don't know whether we have. We have significant portraits of him. I dare say, it is part of their strength that very few can say we are intimates, that applies to all leaders."[126] This is akin to saying that we are always ourselves to ourselves but can only be approximations to others, which makes a portrait that accurately reveals its subject a true rarity.*

PIERRE ELLIOT TRUDEAU · November 4, 1968

*Prime Minister of Canada (1968-1979, 1980-1984), Politician*

I saw him as a dictator first, delivering one of his many speeches. . . . When I photographed him a week after having listened to him, he was very much the man to enjoy the occasion. [127] A magnificent subject: he was magnetic, he was charismatic, he was intelligent. I think you will see the same fanaticism that is among the best of their kind, the leader of a religion, the leader of a cult, or the leader of a revolution. And you see that in the eyes of Castro.[128]

*Karsh's photographs of Fidel Castro were not of an agitated, fanatical revolutionary. As happened many times for Karsh, when the session was going well and the sitter was enjoying the trust he or she felt with a photographer dedicated to seeking positive results, previously guarded facial expressions resurfaced. Castro was a well-read man, and the dictator and the photographer spoke of literature. The Cuban leader was curious about what kind of people Karsh's many sitters were, especially Hemingway, whom Castro had met only once. His curiosity was not about how lighting shapes appearances, but about personal traits. This urge to find insights into political opponents or those culturally inaccessible to him may be an indication of the effects of polarization between the United States and Cuba. In that atmosphere of suspicion, it is not surprising that few sympathetic photographs of the Cuban leader circulated in the American press. When ideologies are inflexible, borders become impenetrable and human understanding dims. It then takes an artist or a diplomat with courage and a constructive attitude to bridge the widening chasm of hatred and mistrust. Here, in this unique portrait, is one man's attempt. If Karsh's image of Castro in a shirtless and pensive pose is a surprise, it is because we are confounded by something contrary to our expectations. The mixed references to classical Greek sculpture, Renaissance pietàs, and the character of Hamlet that our cultural imagination compels us to see also suggest that a fanatical revolutionary, like anyone else, can be the subject of a thoughtful portrait of vulnerability.*

FIDEL CASTRO · August 1, 1971

*Revolutionary, Premier of Cuba (1959-1976), President of Cuba (1976-2008)*

Morley Safer: Is there something a little old-fashioned about the way you work? Karsh: Yes. The human face has not changed since the day I was born.... If I try to be so different at the expense of the subject I'm photographing, I don't believe I would have accomplished what I accomplished.[129]

*Grandson of the twelfth Roppeita Kita, ten-year-old Chiyozo became the fourteenth designated head of the Kita school for Noh actors in 1884. Because the current Kita's own grandson would accept his lineage, Karsh made this rare double portrait, which depicts a living tradition. Always alert to issues of the face, Karsh learned about the role of the main character (shite-kata) in a Japanese Noh drama. "Before each performance the actor removes the mask reverently from its lacquer box, and communes with it before the mirror. This is more than putting on make-up; it is psychological transformation."[130] When Karsh photographed Roppeita Kita XIV, the actor had been active in Noh drama for over eighty years. He had put on the mask countless times. Because of Kita's psychological adeptness, Karsh may have wondered how he could record more than the facial mask the actor would choose to present. The actor's aged hands must have suggested a story of struggle, and his face a story of the peace of triumph. It was true. During a time of social upheaval, Roppeita Kita had rescued his school when it was nearly dissolved as Japan changed from a feudal culture to a modern one. The great actor of impassive tranquility was not inscrutable. The mouth, with the subtlest expression of fulfillment, colors the master's face with warmth and serenity. Karsh, at sixty, was just entering the last period of his own career. Weathering social upheavals of his own time and culture, the old photographer must have been encouraged and humbled to find a kindred spirit in this living national treasure keeping and enriching his tradition as he passed it on to the stewards of its future.*

Roppeita Kita XIV · November 1969

*Noh actor, Intangible National Cultural Treasure (commonly called "National Living Treasure")*

The Japanese have a charming custom; instead of honoring their great men with peerages or knighthoods, they give them the respectful title "living human treasure," that is, a person treasured by the entire nation. Yasunari Kawabata is one such "human treasure," the country's outstanding novelist and winner of the Nobel Prize for Literature in 1968.... After several pictures had been taken, I asked whether he had some work of art that might be included.... And with much ceremony and tenderness he brought out a square wooden box. Inside it lay a piece of funerary sculpture (*haniwa*) about two millennia old, an earthenware portrait of a child's head.... Does he [Kawabata] have a philosophy? [KAWABATA:] "Not exactly, I would rather say [I have] a sense of beauty, a kind of *maborosi*."[131]

*The American philosopher Ralph Waldo Emerson coined a word for the animating spirit of unity in nature and in human nature that drives one's sense of wonder and beauty: oversoul, a non-religious term for god. The Spanish poet Federico García Lorca felt that it was more an impish pest, even a demonic spirit, and used an untranslatable, but common, Spanish term. "Every man and every artist, whether he is Nietzsche or Cézanne, climbs each step in the tower of his perfection by fighting his duende, not his angel as has been said, nor his muse ... one must awaken the duende in the remotest mansions of the blood...."[132] And here we learn from the Japanese novelist another untranslatable term, maborosi, which shares the meaning of vision, mirage, phantom, and trick. It beckons him. Karsh, too, must have wondered what this force was. He was not one to take things apart as analytic thinkers do; he was someone who gathered and assembled. From the photographer we hear stories of encounters and settings, but of the phenomenon itself, not a word. In his pose, Kawabata with his white hair radiates brilliance, and his mouth hints at happiness. But in staring at his eyes, we sense two slightly different moods. The ancient sculpture may have caught this other self, his duende. It proved to be prophetic, and Kawabata took his own life four years later.*

YASUNARI KAWABATA · November 11-19, 1969

*Novelist*

The day of our photographic session proved a difficult one for her. There was student unrest, with the possibility of riots on the Stanford University campus. That morning, she had risen early and spent hours at Stanford trying to calm tempers and keep the situation from exploding; the students loved and respected her; her words did much to restore reason. When we met she looked exceedingly tired. The exacting and anxious hours with the angry students had taken their toll. Before I knew it, she was sound asleep, curled up like a child in a massive leather chair.... As soon as she awakened, she announced brightly, "Now I am ready for the photograph." "No, no," I replied, "not yet . . . refresh yourself; let us listen to some music and let us talk. Then we can settle down to photography."[133]

*Tensions were high on college campuses following the incursion of American troops into neutral Cambodia several days before Karsh's session with Joan Baez. It must have taken all of Baez's energy and persuasion to calm the militant reaction that some students at Stanford University proposed. The day after Karsh photographed Joan Baez, four students were killed by the Ohio National Guard at Kent State University. The whole country was stunned. Back in 1963, at another critical point in American social history, Baez had led the crowd on the National Mall during the March on Washington for Jobs and Freedom in singing "We Shall Overcome." Martin Luther King, Jr., delivered his "I Have a Dream" speech, and the country watched the historic events on television. When Bob Dylan sang "When the Ship Comes In," Baez sang a beautiful non-verbal accompaniment. A portrait of a pacifist, tired but unconquered, is what Karsh captured during a week when the country was frightened about its future. The lilacs that Karsh added are likely to remind knowledgeable viewers of Baez's well-known rendition of the antiwar Pete Seeger ballad, "Where Have All the Flowers Gone?" They serve as a grace note, just as Baez's lyrical soprano voice graced Dylan's insistent message at the Lincoln Memorial seven years before.*

JOAN BAEZ · May 3, 1970

*Folk singer, Pacifist, Activist for civil and human rights*

I was commissioned to photograph him during the Second World War, when he was a naval commander. The prospect of photographing such a giant was awesome. I was so tense and nervous that the first unsatisfactory result made me timorously request a second sitting, to which a patient and understanding Steichen acquiesced.[134]

> Karsh believed that no photographer was more talented, creative, or influential than Edward Steichen. "It was like necessary food to turn to his pages in Vanity Fair for inspiration."[135] Karsh first met Steichen in 1936 during a visit to New York City. Busy as he was, the world's most famous and best paid photographer, Steichen took the time to help the young, unknown Karsh understand how to go about meeting famous personalities and discussed the importance of psychology in portraiture. Karsh's first portrait of Steichen was taken years later in Washington, D.C. while Steichen was serving his country again in another world war. They became closer in the mid-1960s. By this time, Steichen had suffered two strokes and married his third wife, a woman fifty-five years his junior. He had retired to Umpawaug, his Connecticut house and acreage where the Karshs were invited as house guests. Karsh's photograph shows Steichen rowing his young wife with the blooming shadblow tree resplendent in sunlight. Perhaps some of the vigorous health Steichen had enjoyed throughout his life had returned for an afternoon, and he could show his wife that he could properly man a boat. The picture speaks of resurgent life. Steichen's only photographic theme was now recording the seasons as they affected the beloved shadblow tree he had planted thirty years before. Invigorated as the aging photographer may have been that day, he was not on the regenerative track of the seasons. Whatever metaphor of life in which the shadblow figured, Steichen was removed from it. His time was finite and linear, and for him, getting old was not a theme.

EDWARD STEICHEN AND JOANNA STEICHEN UNDER THE SHADBLOW TREE

May 12–13, 1967

*Photographer, Curator*

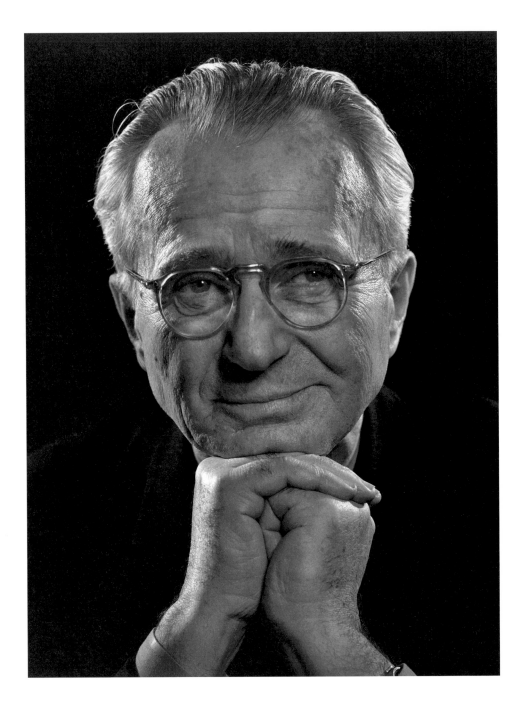

EDWARD STEICHEN · 1944

*Photographer, Curator*

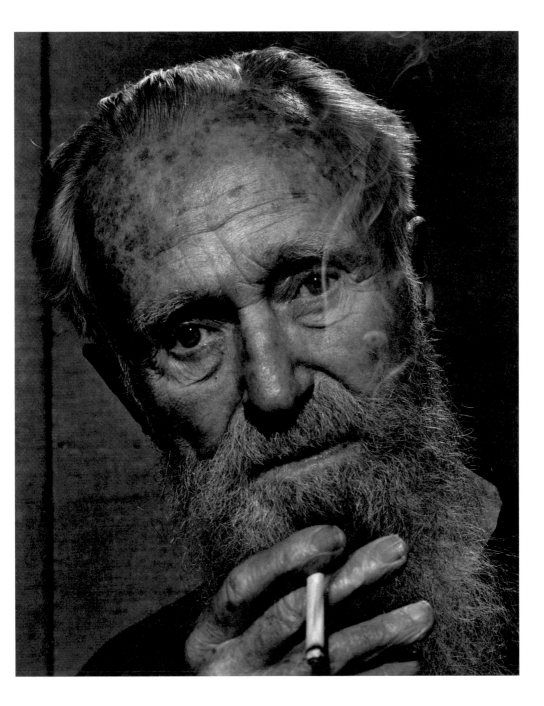

EDWARD STEICHEN · 1970

*Photographer, Curator*

As destiny would have it, she was fascinating to me from our first meeting. I felt her to have the most penetrating and liquidy eyes. I associate with her eyes tremendous depth, and that depth was all knowledge and humor. And ultimately, over a long distance call, which Estrellita has never shied to talk at length, at length, at length, she of all people said, "Now, if you are trying to propose, I accept." And that was the final decision. I have no regret, except a long, long telephone conversation. I have a photograph of her, and that is really a little segment of my vision of her: serene, witty. When her eyes are closed she looks almost subdued. [But] Estrellita is very frank in her description, [and has] very colorful speech.[136]

*This photograph was made in the apartment that the Karshs maintained in New York City, which also served as a studio. They are about to dine at Le Pavillon on Fifth Avenue, one of the most famous French restaurants in the city, to observe Estrellita's fortieth birthday. Though the restaurant was closed on Sunday, Karsh arranged for the chefs of the Four Seasons restaurant to take over the kitchen. As sometimes happened, the photographer spontaneously decided to take a picture. With studio lights and camera nearly in position, it took just a few minutes. At that moment, on that special day, Karsh must have been as taken with her beauty and charm as he was at their first meeting. That was an assignment to photograph Dr. Walter C. Alvarez, a physician and editor of a medical journal who was Estrellita's mentor and collaborator. Here, eight years later, she is leading a different life that takes her around the world, although she still writes articles on medical history and lectures as she did in Chicago. She is now partner, caretaker, and critical intelligence in Karsh's life and continued success. Clothed in a red Moroccan caftan lush with silver and gold, a present from the King of Morocco to the photographer, she overwhelms the spectacular dress with her serenity and beneficence, something her adoring husband treasured and captured effortlessly even in a brief moment before their celebratory dinner.*

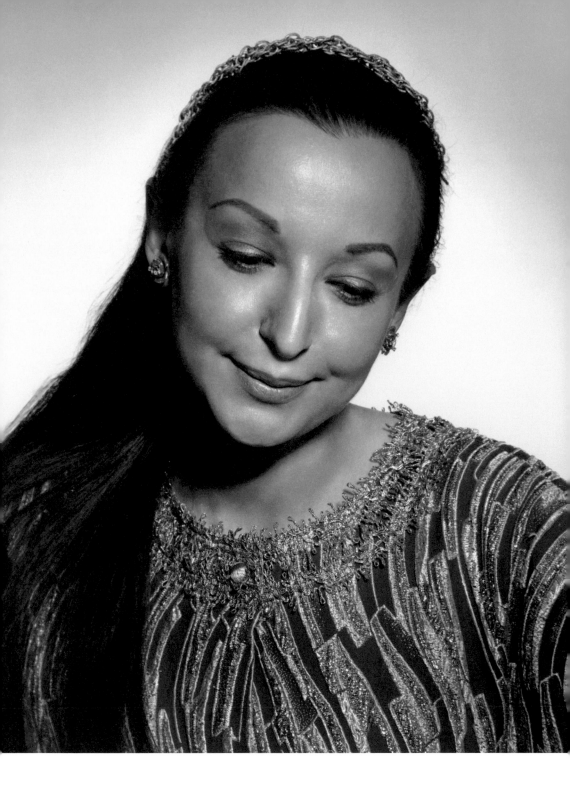

Estrellita Karsh · June 19, 1970

*Wife of the photographer, Medical Writer, Philanthropist*

After viewing this photograph, the Duke and Duchess graciously wrote to me that I had captured their deep feelings for each other after thirty-four years of marriage.[137]

No matter how renowned his sitters were, Karsh was fascinated with discovering more about human beings through the mystery of facial expressions. With celebrities, he portrayed their known character traits, but endeavored to reveal something no one else knew. Try as he might, he could not fit every aspect of a complicated subject into one image. In his portrait of the controversial Duke and Duchess of Windsor, Karsh chose to make a semiformal portrait that spoke of their unwavering love for each other. In 1936, the Duke acted with political illogic in his abdication, which ingratiated him with romantics who cherished the fact that it was for love that Edward VIII gave up the throne. Some viewed the couple with disdain while others questioned their political allegiance; British Intelligence and the FBI suspected they held pro-German sympathies before and during the Second World War.[138] Later in 1956, the gossip columnist Elsa Maxwell, reviewing the Duchess's autobiography, The Heart Has Its Reasons, said that she "seeks to compensate for all she hoped for and lost with an almost feverish pursuit of pleasure. . . . Many of the things she has done in this search, largely because of the high-handed, selfish way in which she has done them, have contributed to her final frustration – the fact that the Windsors' prestige is not what it used to be and the Windsors' romantic aura is sadly diminished."[139] If the aura was gone, the romance remained. Karsh saw it in her eyes. Although their character and mystique had been savaged, she still possessed the mesmerizing trance of love that he could not resist. For the photographer and his subjects, Blaise Pascal's centuries-old remark remained the only answer they need give: "The heart has its reasons, which reason does not know."[140]

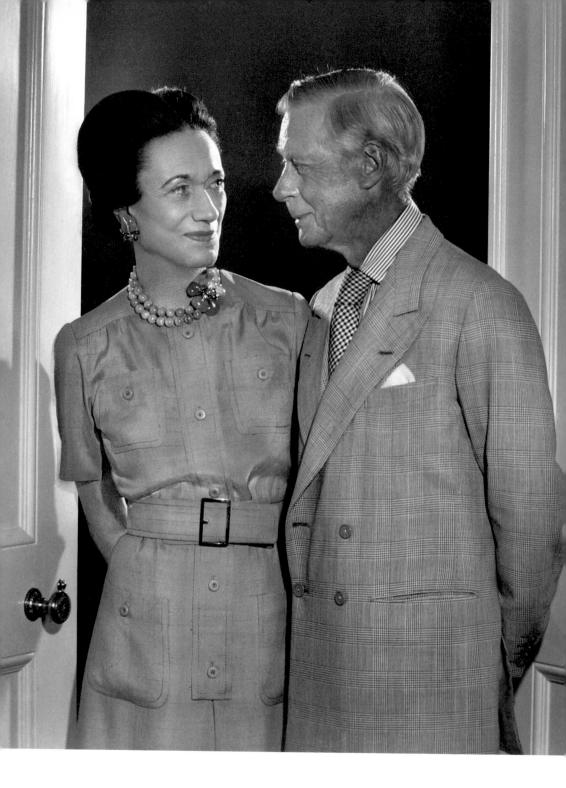

THE DUKE AND DUCHESS OF WINDSOR · 1971

*King of Great Britain (January 20-December 11, 1936) and Wife , Wallis Simpson*

W.H. Auden, I photographed in London. He was very sick at the time and spoke of death. I photographed him in the home of his poet colleague Stephen Spender. We started the photography, but for the first time in many, many years the electronic flash would not function. So I invited the poet to come to the garden, and late, late in the evening, I was able to take a simple snapshot of him. But it shows his great strength, great character. I believe it was Henry Moore who said his face was like the furrows of the earth.[141]

*This photograph of W.H. Auden was taken a year before his death. Those who know the poet's work will remember the lines from his poem "In Memory of W.B. Yeats" (1939): "Follow, poet, follow right / To the bottom of the night, /With your uncon-straining voice / Still persuade us to rejoice."[142] But something written so long ago for someone else was not likely to be among Auden's thoughts in 1972. It is just an apt coincidence that we might associate them with his pensive face and uplifted chin in the dwindling light. Auden believed, "So long as a man writes poetry or fiction, his dream of Eden is his own business."[143] The fiction of rejoicing that Karsh hints at in this portrait is what the photographer sought for himself in his own work. Despite Auden's talk of death, the stubbornness of his hope – this necessary human fiction – is what makes the poet's voice ring true. Karsh shares the same hope, showing us a poet at the end of the day, still within the Eden of his companion's garden. All of that is called to mind by an image the photographer dismissed as a simple snapshot. Beyond the powerful expression in the portrait, this photograph from a small, hand-held camera demonstrates that a tool made for other purposes does not have to define the picture it produces. The experienced photographer discards its split-second acrobatics and coerces it into registering the solemnity of reflection and repose, which Karsh proves so extraordinarily capable of with his sturdy studio camera.*

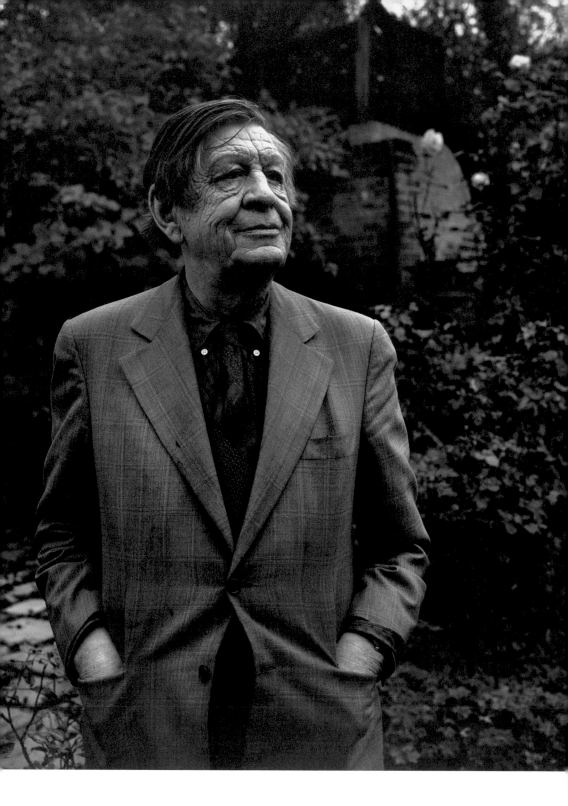

W. H. AUDEN · October 30, 1972

*Poet*

He's a very colorful man, and a man diversified, versatile, [of] great accomplishment. . . . He's a good combination, he's an American citizen, Irish mother, and Japanese father. I mean how much more civilization can you crowd into one body. That doesn't make him pure American, but almost pure American.[144]

*Artists with sculptural skill and vision possess a special kind of imagination. They do not make images, but take existing materials and turn them into something else. It seems a simple idea, but it has complex philosophical underpinnings. Philosophers question whether the things we sense as objects exist independently of us or are figments of our perception. Some use the word "ontic" to propose that an object simply exists within Nature. The term "ontological" then means how something exists, or has its own "nature." The face of a head may be considered ontic; ontologically, it may be photogenic. Giorgio Vasari wrote that within a piece of unformed marble ruined by another sculptor, Michelangelo saw the splendid figure of his David. "It is certainly a miracle that a stone without any shape at the beginning should ever have been reduced to a perfection as Nature is scarcely able to create in the flesh."[145] For a photographer, things are not so straightforward. Many viewers insist that photography measures only the "ontic world" as a mechanical image. Nevertheless, we sense more than objects or spaces. In Karsh's portrait, Noguchi is positioned between a dark block of rough-hewn sculpture and the light of his studio window. Knowing the story of Michelangelo's David, Noguchi may be asking us to see his sculpture both as a material object and as an exercise to decipher the nature of what the stone contains - a perfect ontic/ontological puzzle. The photographer does the same with his portrait of the stony-faced artist by opposing the static block of stone with the sun streaming through the window, suggesting that either Noguchi is as dead and immobile as stone or alive with inner illumination and thought - something the photographer leaves for us to decide, as always.*

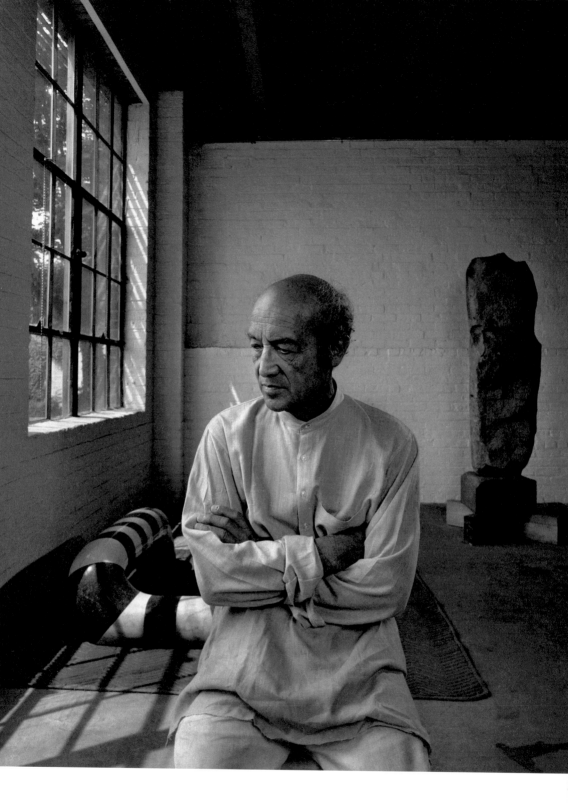

ISAMU NOGUCHI · June 25, 1980

*Sculptor, Landscape architect, Designer*

Of his satire on American values, *Lolita*, he drolly commented, "I know the American woman very well. When I was a butterfly scientist I taught many of them during their crucial years in college."[146] Nabokov is a brilliant writer, and [a] prolific writer. As a human being, he left much to be desired. He is among the least attractive men I have ever photographed. His manners, his thinking, his arrogance, his false behavior [were objectionable to me].[147]

*No trace of Karsh's negative opinion of Nabokov shows in this portrait. One reason may be that such traits remained masked during the session. But knowing that highly skilled portrait photographers can find subtle "tells" in the face – like poker players do – and coax them onto film, one is left to assume that Karsh was not in the business of making such exposés in his photographs. He endeavored to discover a positive aspect in each of his subjects. It was a kindness of sorts and part of Karsh's life-long habit of not acting on dislike or hatred. One can find Karsh portraits that are unsuccessful, but none that are mean-spirited or cynical. During the genocide that he witnessed as a boy against his family and other Armenians, his mother taught him not to seek revenge, even on those who hurt him. She understood his rage and taught him that if he were to throw a stone back at them in anger, to be sure that he missed. As a man, Karsh had his opinions of those he encountered, but it is rare that he voices them as he does in this reminiscence sixteen years after the encounter. Such emotions are never in his photographs. As difficult as the session may have been for him, he does not take aim at his sitter, but rather allows Nabokov to have his way. Nabokov in a comfortable and ingrained self-assuredness takes aim at Karsh and his camera so confidently that his stare goes through them both and out of the print straight into the eyes of viewer – one to one – where a writer always has his say.*

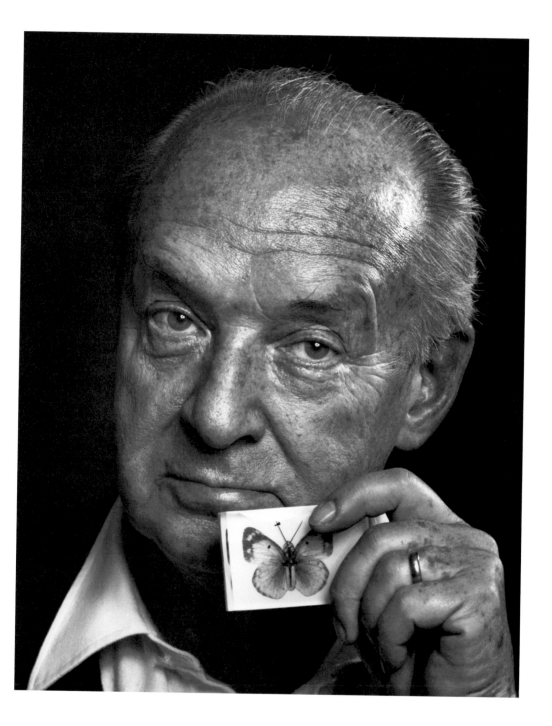

VLADIMIR NABOKOV · November 3, 1972

*Novelist, Lepidopterist, Chess analyst*

I had photographed him as a dancer [before]. He is a glorious dancer. [This photograph] was soon after he had taken the role of Rudolph Valentino [for a Ken Russell film]. So, I said, "You have taken the role of the most famous lover of the twentieth century. Let's look at those sensuous lips of yours." And that's the mischievous attitude he gave me.[148]

*When Nureyev remembered his ballet teacher at the Kirov School in Leningrad from the mid-1950s, he said that the master did not rely on method but rather provoked him into dancing. Here we see another master at work with the dancer. Karsh's teasing provocation about the dancer's sensuous lips resulted in a reaction that the photographer could not have easily anticipated. An aspect of the dancer's spontaneity appeared, and it was welcome. It made the portrait. Even experienced photographers with well-honed reflexes do not do well when trying to anticipate the unpredictable. Their tactic is rather to lie in wait and watch with heightened awareness. That is their best chance to capture a visual event as it flashes before them or unfolds unpredictably in an evolving sequence. Even portrait photographers working with unwieldy, large-format cameras need to make split-second decisions like sports photographers with single lens reflex cameras. The impulsive and mischievous Nureyev does not catch the photographer off guard with his impromptu reaction. Karsh is waiting for whatever might result, and seeing it, instantly presses the shutter, arresting the fleeting moment of Nureyev's magical gesture and expression. What we cannot see, but may imagine, is perhaps an unspoken rapprochement between two immigrants. Both had traumatic early childhoods in parts of the world remote from where they trained and would make their talents known. Paupers who became princes, each one carrying with him a classical training and speaking with deliberation and care in ancient accents. They were transformed and created new experiences for their modern audiences.*

RUDOLF NUREYEV · September 21, 1977

*Ballet dancer*

I usually shy away from photographing a family group. . . . A fellow Armenian telephoned from San Francisco, an oral surgeon. He telephoned more than once to prevail upon my secretary [asking] if I could go to San Francisco and photograph his family. The Moomjians turned out to be a charming family, attractive children, hospitable, and natural hosts. [One photograph] shows a very healthy young American boy, full of zest, inquisitive curiosity, and questions I could not keep up with to answer. I photographed this bundle of energy.[149]

*Karsh thought enough of this portrait to include it in the book and exhibition cele-*
*brating his sixtieth anniversary as a photographer. Publishers usually organized*
*Karsh's later books according to subjects, but Karsh had no special category for this*
*portrait. Stephen Moomjian was not a head of state, an author, a musician, a scien-*
*tist, or an artist. He was not a prince, like Charles, the three-year-old son of Princess*
*Elizabeth, whom Karsh had photographed with his parents in 1952. Nor was he a*
*child actor, like Margaret O'Brien. When Karsh met Stephen, he was just a child full*
*of the joy of life. That was enough for the photographer, who had had a joyless and*
*traumatic childhood in Armenia. For whatever reason, children fascinated Karsh,*
*and he fascinated them. His eyes were always directed to them, following their every*
*move; the complete attention a child craves was theirs. The method for realizing their*
*personalities in a picture had to be on their terms. The challenge was to get them to*
*hold still long enough for a studio photograph that retained their vitality. Karsh*
*remembers Stephen as an "energetic little boy in perpetual motion," but does not*
*reveal what amount of patience, serendipity, charm, skill, or conniving was required*
*to get his active subject "to alight for one fleeting moment on his nonstop itinerary."[150]*
*A watchful eye and the reflexes Karsh had honed in photographing restless children*
*in the early years of his Ottawa studio were at his command. So were his patience*
*and perception. They had to be. They were essential for his successes with adults.*

STEPHEN MOOMJIAN · March 1-4, 1979

*Child of an oral surgeon*

One moment she was a disciplined goddess and diva, adept at creating before my camera the illusion of imposing majesty befitting the operatic heroines she portrays. The next, relaxed and at rest between photographs, she was disarmingly girlish, enthusiastic, and free of prima donna pretense. She spoke of her magnificent voice almost as a separate entity – a unique God-given gift – to be cared for, protected, and, when necessary, mollified.[151]

*Jessye Norman's musical heritage is gospel music. Audiences all over the world wanted to hear it sung, as she said, from a black mouth. When Norman began her career, unlike her hero Marian Anderson, she was unencumbered by racism in the opera world. She did not have to be a saint and was free to be either girlish or diva-like for her sitting. Karsh also played a role. At age eighty-two, he was the experienced partner guiding Norman to an expression of self-reflective poise in a way that few younger photographers could. The resulting mood is one that recalls the lines Norman had sung in Richard Strauss's "Four Last Songs" from Herman Hesse's poem "September": "Leaf after golden leaf drops down from the high acacia tree. / Summer smiles surprised and weary upon the dying dream of this garden. / Yet still it lingers by the roses longing for rest / Then slowly closes its great weary eyes." To reach this level of expression required an older photographer and a subject worthy of his gifts. As ever, Karsh brought his charm and respect to the encounter. Knowing of his legendary kindness, Norman brought her trust and drew upon the depths of her experience and artistry to reveal something integral to her self. This was an opportune beginning, and Karsh knew just what else was needed. In the last years of his career, his kinship with tradition did not fail him. He called once again upon his old-fashioned belief that seeking to show the goodness in people remained a virtue essential to making portraits enduring and, more importantly, to making life worth living.*

JESSYE NORMAN · April 4, 1990

*Soprano*

JERRY FIELDER: [Canadian Prime Minister] Brian Mulroney greeted Mandela at the airport and accompanied him to the Château Laurier. We were waiting in the lobby and the introductions were made. When the session started an hour later, Mandela was warm and friendly but obviously very tired. Yousuf then told him a story about Pope John XXIII. He had asked the Pontiff, "How many people work in the Vatican?" The Pope smiled and replied, "About half." Mandela looked a little blank. Suddenly he got the joke, slapped the table, and roared with laughter. And everything about the sitting changed.[152]

*Nelson Mandela was released from a life sentence on February 11, 1990. On June 16, he landed in the Netherlands to thank that country for its support of his struggle against apartheid. The next day, he flew to Ottawa to address a joint session of Parliament and to ask for continued sanctions against South Africa. Almost half a century before, Winston Churchill had addressed the country in this way, and Karsh began his international career. Mandela was seeking aid too. Initially influenced by Gandhi's nonviolent philosophy, Mandela had led a campaign of passive resistance to abolish apartheid. In 1960 the Sharpeville Massacre and the declaration of state-of-emergency law redirected his efforts towards sabotage that did not involve taking human lives. Sometime during his twenty-seven-year incarceration, he regained the vision of nonviolence as the pathway to national unity. Although Mandela is a dramatically rendered subject in Karsh's photographic career, there is a connection that goes beyond the camera. Despite the murder of two uncles and the constant torment Karsh received from Turkish boys, his mother engrained in Karsh the need for forgiveness, making him realize that revenge could never lead to reconciliation but only further violence. Now it was Mandela's hour on the world stage. Could what Karsh had grasped at the beginning of the century as a boy be achieved at its end by an elder statesman from a country so bloodied and deeply divided? The man who had learned to smile for photographers disguising his long suffering and impossible challenges was about to find out.*

NELSON ROLIHLAHLA MANDELA · June 17, 1990
*Nobel Peace Laureate (1993), President of South Africa (1994-1999)*

# ACKNOWLEDGMENTS

Trying to understand a photographer from his or her photographs is a difficult task because their works are seldom intended for such a reading. I have had the advantage of working for several years with one of the major influences in Karsh's life, his second wife Estrellita Karsh. Like Karsh's first wife, Solange, Estrellita had a long marriage with the photographer (1962–2002). Karsh was a man of enormous talents who needed the partnership he found in his two remarkable wives.

I have profited enormously from Estrellita's council because of her experiences as a professional writer. She has shared her recollections and perceptions, and she has confirmed facts for my research and texts. Nothing substantial regarding the appreciation and understanding of Karsh would be possible without her. I have also had the good fortune to work closely with Jerry Fielder, who for twenty-five years was Karsh's studio assistant and was present at many of the portraits taken from the late 1970s until the photographer's death in 2002. Fielder has carried on his devotion to Karsh and his photographs through his curatorial work, writing, lecturing, and administration of the Karsh Estate. His intimate knowledge of the way Karsh thought and functioned during a portrait session and his informed and well-reasoned judgment of the work are resources only a few writers have had the good fortune to share.

The third key member of what I have come to call the Karsh team is David R. Godine, a long-time friend and colleague, who published my book *Yousuf Karsh: Regarding Heroes*, and was willing to try another kind of book that was not a repackaging of the first. Working with me every step of the way were others members of the team. Jennifer Delaney guided the production of the book with equal parts of expertise and patience. Carl W. Scarbrough conceived of our story physically with his beautiful sense of design and typography. Jean Genoud, extraordinary printer and long-time friend of the photographer, supervised another exquisite printing of the photographer's work. Charles Britt and Jason Christian worked on the preparation of the photographs; Susan Barba managed the editorial process; and Meghan Angelos served as my intern and researcher.

None of my ideas would have reached any clarity without the contribution of my wife, Leslie Travis, who is the primary reader of all I publish. Her perception and good sense have untangled many unwieldy sentences and restored them to the single idea that prompted them, which is something that at a certain point writers cannot do for themselves.                                    D. T.

## TECHNICAL NOTE

"To make enduring photographs, one must learn to see with one's mind's eye, for the heart and the mind are the true lens of the camera." That is what Yousuf wrote from long experience and what should come first as we think about his portraits.

His camera of choice was large format: 8 by 10 with an interchangeable 4 by 5 back. The developers were to his own formulas because that is what he learned from his early years with George Nakash and John Garo - no Kodak packages. For negatives, he used special chemicals that allowed a faint green light to reveal the deepening densities so he could judge each one individually. For prints, he had two developers, "hard" and "soft", and sometimes both would be used on the same photograph - one to bathe the print, and the other to be applied in specific areas with a piece of cotton.

He preferred tungsten lights because he could see the results playing across the faces of his subjects, and they were less disruptive than the flash of strobes. I would always set up the lights and camera in the same way so he knew instinctually where everything was. It was like an artist who places paints in the same order on his palette to concentrate fully on the canvas. Yousuf would then make adjustments as the sitting progressed - sometimes minor, sometimes major, but never the same.

He worked with one assistant when traveling or in the studio so as not to break the concentration with his subject - no entourage for hair, make-up, or styling. He was in charge, no matter his subject, and he chose the locations and set-ups.

Once the lighting and composition were to his satisfaction, he would leave the camera with the shutter release innocently in his hand and engage his subject, ready to squeeze the bulb, capture a moment of truth, and share it with us.

JERRY FIELDER
*Monterey, California*

# NOTES

1   Blaise Pascal, *Pensées*, intro. T. S. Eliot (New York: E. P. Dutton & Co., Inc., 1958), 29.

2   Yousuf Karsh, interview with Don Michel, *Insight* radio program, WRAJ, Anna, Illinois, December 30, 1974, audio cassette recording at 2:13, Yousuf Karsh Estate. Karsh continues "... because at the time, [a] birthday did not count for much because we were very proud and happy to be alive."

3   Karsh relates this and other horrors in his autobiography, *In Search of Greatness, Reflections of Yousuf Karsh* (New York: Alfred A. Knopf, 1962), 9–14.

4   Ibid., 11.

5   Ibid., 12–13.

6   For a discussion of the reasons the Karsh family were able to stay in Mardin past the worst of the massacres see Maria Tippet, *Portrait in Light and Shadow: The Life of Yousuf Karsh* (New Haven: Yale University Press, 2007), 15–20.

7   Arabic was the only language permitted for public exchange in Turkey at the time of Karsh's boyhood. Armenian was heard only in church or in the guarded privacy of families and close friends.

8   Yousuf Karsh, *In Search of Greatness*, 5.

9   *Karsh: The Searching Eye*, dir. Harry Rasky, 1986 (at 12:10).

10  By 1928, these techniques were employed only by a generation of older photographers, but still admired by sitters who were flattered as much by having been part of the battle to establish photography as an art as by their unique appearances.

11  Karsh, interviews with Jerry Fielder, August and September 1988, audio cassette, Yousuf Karsh Estate.

12  Karsh, interview with Morley Safer at the International Center for Photography, 2000, audio cassette recording at 4:20, Yousuf Karsh Estate.

13  John Powis was a portrait photographer in Ottawa in the fall of 1932, when Karsh became his assistant. Powis was well established and had a prestigious clientele. His portraits were reproduced in the society pages of several magazines, including *Saturday Night*, a nationally distributed magazine, and he was even allowed to reproduce the coat of arms of no fewer than three Governor Generals of Canada on his folders.

14  Tippet, *Portrait in Light and Shadow*, 66.

15  This portrait was taken in August 1946 but was probably not included in Yousuf Karsh, *Faces of Destiny: Portraits by Karsh* (Chicago: Ziff-Davis Publishing Company, 1946) because the book was already in production.

16  The ten photographers mentioned in the article "Who Are the World's 10 Greatest Photographers?" were Ansel Adams, Richard Avedon, Henri Cartier-Bresson, Alfred Eisenstaedt, Ernst Haas, Philippe Halsman, Yousuf Karsh, Gjon Mili, Irving Penn, and W. Eugene Smith. Edward Weston had died on New Year's Day 1958.

17  Karsh's printing technique began with the way he balanced light and the exposure he made creating a negative that was thin by most standards. He developed his negatives by inspection to ensure that they would match his way of printing. In making positives, he was careful not to block up the darker gray tones and would sometimes use two kinds of developers dabbed on areas of the print to vary the contrast and tone. It was meticulous work and could be exhausting and frustrating. After years of making his own master prints, he gradually trusted long-experienced employees to also print from his negatives, but only if he closely supervised them and critically examined what they produced. His chief printer, Ignas Gabalis, was a perfectionist like Karsh and was with the studio for forty years (1952–1992) matching Karsh's unsurpassed examples.

18  Yousuf Karsh, *Portraits of Greatness* (Toronto: University of Toronto Press, 1959), 46.

19  Karsh, *In Search of Greatness*, 16. This was a recollection of Karsh's experience during his single semester at Sherbrooke High School.

20  Karsh, interview with Don Michel, December 1974, audio cassette recording at 6:36, Yousuf Karsh Estate.

21  "Vanity. I think it is welcome. I rather like it about people. They know their own worth, they know their presence in life, they know their role in life." Karsh, interview with Morley Safer, 2000, audio cassette recording at 18:33, Yousuf Karsh Estate.

22  Karsh, interview with Morley Safer, 2000, audio cassette recording at 19:55, Yousuf Karsh Estate.

23  Howard Garner counts interpersonal relationships as one of the seven main categories of his definition of intelligence. See Howard Garner, *Frames of Mind: The Theory of Multiple Intelligences* (New York: Basic Books, 1993).

24  Karsh, interview with Morley Safer, 2000, audio cassette recording at 38:45, Yousuf Karsh Estate.

25  Michel de Montaigne, "On Presumption" in Michel de Montaigne, *Essays*, trans. by J.M. Cohen (New York: Penguin Books, 1958), 208.

26  Karsh, interview with Morley Safer, 2000, audio cassette recording at 30:15, Yousuf Karsh Estate.

27  Karsh, interviews with Jerry Fielder, August and September 1988, audio cassette, Yousuf Karsh Estate.

28  Karsh, interview with Don Michel, December 1974, audio cassette.

29  Karsh, interview with Morley Safer, International Museum of Photography, audio cassette recording on October 26, 1992, on the occasion of the *American Legends* exhibition and publication, Yousuf Karsh Estate.

30  Karsh, *In Search of Greatness*, 162.

31  Ibid.

32  Ibid.

33  *Yousuf Karsh, A Biography in Images*, commentary by Jerry Fielder, (Boston: MFA Publications, 2003), 77.

34  Karsh, *Faces of Destiny*, 38.

35  Karsh, interviews with Jerry Fielder, August and September 1988, audio cassette, Yousuf Karsh Estate.

36  Ibid.

37  Ibid.

38  George Bernard Shaw quoted in *1000 Photo Icons*, The George Eastman House (Cologne: Taschen, 1999), 420.

39  Karsh, *Faces of Destiny*, 130.

40  Ibid., 154.

41  Karsh, interviews with Jerry Fielder, August and September 1988, audio cassette, Yousuf Karsh Estate.

42  *Eleanor and Harry: The Correspondence of Eleanor Roosevelt and Harry S Truman*, ed. Steve Neal (New York: Scribner, 2002) 16.

43  Karsh, interview with Connie Martinson for Connie Martinson Talks Books, 1983, available online at http://ccdl.libraries.claremont.edu/cdm/singleitem/collection/cmt/id/332/rec/1.

44  Karsh, *Faces of Destiny*, 144.

45  Karsh, interviews with Jerry Fielder, August and September 1988, audio cassette, Yousuf Karsh Estate.

46  Ibid.

47  Ibid.

48  Ibid.

49  Jill Ker Conway, *Written by Herself: Autobiographies by American Women*, An Anthology (New York: Knopf Doubleday Publishing Group, 1992), 77.

50  Karsh, *Portraits of Greatness*, 16.

51  Yousuf Karsh, *A Sixty-Year Retrospective* (Boston: Little, Brown and Company, 1996), 176.

52  Karsh, interview with Morley Safer, International Museum of Photography, October 26, 1992, Yousuf Karsh Estate.

53  Karsh, interviews with Jerry Fielder, August and September 1988, audio cassette, Yousuf Karsh Estate.

54  Donald Hall, "William Carlos Williams and the Visual," *Poetry and Ambition, Essays 1982-88* (Ann Arbor: The University of Michigan Press, 1988), 123.

55  Karsh, interviews with Jerry Fielder, August

and September 1988, audio cassette, Yousuf Karsh Estate.

56  Humphrey Bogart, quoted in Stephen Humphrey Bogart, *Bogart: In Search of My Father* (New York: G. K. Hall, 1995), 137.

57  Karsh, interviews with Jerry Fielder, August and September 1988, audio cassette, Yousuf Karsh Estate.

58  David O. Selznick, *Memo from David O. Selznick*, ed. Rudy Behlmer (New York: Viking Press, 1972), 132. From a letter to William Herbert, advertising and publicity director for Selznick International, dated June 22, 1939.

59  Karsh, interviews with Jerry Fielder, August and September 1988, audio cassette, Yousuf Karsh Estate.

60  Karsh, *A Sixty-Year Retrospective*, 167.

61  Allan R. Ellenberger interview with Margaret O'Brien on the author's blog, "Hollywoodland: A Site About Hollywood and its History," posted as Part II on January 17, 2011: http://allanellenberger.com/book-film-news/an-interview-with-margaret-obrien-part-two/. See also Allan R. Ellenberger, *Margaret O'Brien, A Career Chronicle and Biography*, (Jefferson, NC: MacFarland & Co., 2000), interview with Margaret O'Brien.

62  Karsh, interviews with Jerry Fielder, August and September 1988, audio cassette, Yousuf Karsh Estate.

63  Bob Thomas, *Joan Crawford, A Biography* (New York: Bantam Books, 1978), 125. Harry Brandt, an owner of several theaters, wrote an article in the *Independent Film Journal*, February 1938, titled "Box Office Poison" naming Mae West, Edward Arnold, Greta Garbo, Joan Crawford, Katharine Hepburn, Marlene Dietrich, and many others.

64  Karsh, *Portraits of Greatness*, 68.

65  G. H. Hardy, *A Mathematician's Apology* (Cambridge, UK: Cambridge University Press, 1967), 85.

66  Karsh, *Portraits of Greatness*, 68.

67  Karsh, *A Sixty-year Retrospective*, 141.

68  Karsh, interview with Don Michel, December 1974, audio cassette.

69  Karsh, interview with Katherine Plake (Hough), March 1981, audiovisual cassette recording for an exhibition at the Palm Springs Desert Museum (presently Palm Springs Art Museum), Yousuf Karsh Estate.

70  Wallace Stevens, from "Adagia," *Wallace Stevens: Collected Poetry and Prose*, (New York: The Library of America, 1997), 903.

71  Wallace Stevens, "The Idea of Order at Key West," *Wallace Stevens: Collected Poetry and Prose*, 106.

72  Karsh, interview with Don Michel, December 1974, audio cassette.

73  Karsh, *Portraits of Greatness*, 108.

74  Ibid.

75  Karsh, *Karsh: The Searching Eye*.

76  Karsh, *In Search of Greatness*, 144–45.

77  Ibid., 145.

78  Karsh, interviews with Jerry Fielder, August and September 1988, audio cassette, Yousuf Karsh Estate.

79  François Mauriac, "The Art of Fiction" interview, *The Paris Review* 1, no. 2 (summer 1953), 33. This quote precedes the interview and is taken from a statement the writer made in *La Table Ronde* in August 1949.

80  Karsh, *Portraits of Greatness*, 170.

81  Ibid.

82  Karsh, interview with Morley Safer, International Museum of Photography, October 26, 1992, Yousuf Karsh Estate.

83  Karsh, *Faces of Destiny*, 64.

84  Yousuf Karsh, *Industrial Images*, essays by Cassandra Getty and Jerry Fielder (Windsor, Canada: The Art Gallery of Windsor, 2007), 19.

85  Karsh, *A Sixty-Year Retrospective*, 96.

86  Tippett, *Portrait in Light and Shadow*, 258. The politician quoted here is W. Chester S. McLure who represented Queen's district on Prince Edward Island.

87  Karsh, interviews with Jerry Fielder, August and September 1988, audio cassette, Yousuf Karsh Estate.

88  Yousuf Karsh, "A Moment in Time" from the series *Life and Times*, the Canadian Broadcast

Corporation, October 3, 2000, audiovisual cassette, Yousuf Karsh Estate.

89  Karsh, interview with Connie Martinson for *Connie Martinson Talks Books*, 1983.

90  Janet Flanner, *Paris Journal, 1944-1955*, ed. William Shawn (New York: Harcourt Brace Jovanovich, 1988), 82.

91  Gertrude Stein, *Paris France* (New York: Liveright, 1970), 11.

92  Karsh, interviews with Jerry Fielder, August and September 1988, audio cassette, Yousuf Karsh Estate.

93  Karsh, *A Sixty-Year Retrospective*, 157.

94  Karsh, *Portraits of Greatness*, 32.

95  Ib Melchior and Lauritz Melchior, *Lauritz Melchior: The Golden Years of Bayreuth* (Fort Worth, TX: Baskerville Publishers, 2003), 103.

96  Karsh, *Portraits of Greatness*, 156.

97  Wallace Stevens, from "Adagia," *Wallace Stevens: Collected Poetry and Prose*, 906.

98  Yousuf Karsh, *Portraits of Greatness*, 112.

99  Karsh, interviews with Jerry Fielder, August and September 1988, audio cassette, Yousuf Karsh Estate.

100  Ibid.

101  Karsh, *Portraits of Greatness*, 202.

102  Ibid.

103  Karsh, interview with Katherine Plake (Hough), March 1981, Yousuf Karsh Estate.

104  Morley Safer, interview with Yousuf Karsh, *60 Minutes*, 1977, audiovisual cassette, Yousuf Karsh Estate.

105  Karsh, *Portraits of Greatness*, 98.

106  Barry Paris, *Audrey Hepburn* (New York: G. P. Putnam's sons, 1996), 364. These are the first three lines of "Time-Tested Beauty Tips" by Sam Levenson, written for his grandchild.

107  Karsh, *A Biography in Images*, 137.

108  Billy Wilder quoted in Tony Nourmand, *Audrey Hepburn, The Paramount Years* (San Francisco: Chronicle Books, 2007), 90.

109  Karsh, interviews with Jerry Fielder, August and September 1988, audio cassette, Yousuf Karsh Estate.

110  Ibid.

111  Karsh, *A Biography in Images*, 135.

112  Yousuf Karsh, interviewed by Larry King on *CNN Weekend*, January 5, 1994.

113  Karsh, *A Biography in Images*, 85.

114  Lady Jeanne Campbell, "Magic Majesty of Mrs. Kennedy," *The London Evening Standard*, November 25, 1963, 1.

115  President John F. Kennedy, 12th News Conference, Palais de Chaillot, Paris, June 2, 1961.

116  Theodore H. White, *In Search of History: A Personal Adventure* (New York: HarperCollins, 1978), 524-525.

117  Karsh, interviews with Jerry Fielder, August and September 1988, audio cassette, Yousuf Karsh Estate.

118  Jacqueline Kennedy, *Historic Conversations on Life with John F. Kennedy* (New York: Hyperion, 2011), 243.

119  Ibid., 58.

120  Karsh, interview with Don Michel, December 1974, audio cassette.

121  Karsh, *Portraits of Greatness*, 54.

122  Ibid., 74.

123  Karsh, interview with Don Michel, December 1974, audio cassette.

124  William J. Thomson, *Khrushchev: A Political Life*, (New York: St. Martin's Press, 1995), 150.

125  Karsh, interviews with Jerry Fielder, August and September 1988, audio cassette, Yousuf Karsh Estate.

126  Karsh, *Karsh: The Searching Eye*.

127  Ibid.

128  Karsh, interview with Morley Safer, *60 Minutes*, 1977, audiovisual cassette, Yousuf Karsh Estate.

129  Karsh, interview with Morley Safer, International Museum of Photography, October 26, 1992, Yousuf Karsh Estate.

130  Karsh, *A Biography in Images*, 128.

131  Karsh, *Faces of Our Time*, 82.

132  Karsh, *Karsh: The Searching Eye*.

133  Federico García Lorca, "Play and the Theory of the Duende," *In Search of Duende* (New York: New Directions, 1998), 50-51.

134  Karsh, *Faces of Our Time*, 22.

135  Karsh, *A Sixty-Year Retrospective*, 125.

136  Karsh, *Faces of Our Time*, 186, originally quoted in an article for *US Camera*, 1967.

137  Karsh, *A Sixty-Year Retrospective*, 18.

138  "Windsor, Duke and Duchess," Federal Bureau of Investigation, http://foia.fbi.gov/foi-aindex/windsor.htm.

139  Anne Sebba, "Wallis Simpson, 'That Woman' After the Abdication," *New York Times Style Magazine*, November 1, 2011.

140  Blaise Pascal, ed. and trans. Roger Ariew, *Pensées* (Indianapolis: Hackett Publishing Company, 2004), 216.

141  Karsh, interviews with Jerry Fielder, August and September 1988, audio cassette, Yousuf Karsh Estate.

142  W. H. Auden, "In Memory of W. B. Yeats," *The Collected Poetry of W. H. Auden* (New York: Random House, 1945), 51.

143  W. H. Auden, *The Dyer's Hand and Other Essays* (New York: Random House, 1968), 6.

144  Karsh, interview with Katherine Plake (Hough), March 1981, Yousuf Karsh Estate.

145  Giorgio Vasari, trans. Gaston du C. de Vere, *The Lives of the Most Excellent Painters, Sculptors, and Architects* (New York: The Modern Library, 2006), 350. Here Vasari is referring to Michaelangelo's *Pietà* of 1498–99.

146  Karsh, *A Sixty-Year Retrospective*, 34.

147  Karsh, interviews with Jerry Fielder, August and September 1988, audio cassette, Yousuf Karsh Estate.

148  Karsh, interview with Connie Martinson for *Connie Martinson Talks Books*, 1983.

149  Karsh, interviews with Jerry Fielder, August and September 1988, audio cassette, Yousuf Karsh Estate.

150  Karsh, *A Sixty-Year Retrospective*, 103.

151  Karsh, *A Biography in Images*, 139.

152  Jerry Fielder, email to author, November 28, 2011.

# INDEX

*(Page numbers refer to the text entry for each subject)*

## A Note on the Type

Karsh: Beyond the Camera has been set in Mentor and Mentor Sans, a family of types designed by Michael Harvey for Monotype. An accomplished designer of typefaces, Harvey began his career as a lettercarver, working as an assistant to Reynolds Stone in the late 1950s. He designed his first dustjackets in 1957, moving on to design his first type, Zephyr, in 1961, at which time he also began teaching lettering arts. Awarded the MBE for services to art in 2001, Harvey remains a prolific designer and continues to carve inscriptional lettering as well. ⋮ ⋮ With their meticulous drawing and strong calligraphic vocabulary, the Mentor types reveal a close study of the work of Eric Gill and Hermann Zapf, yet their stylish letterforms – especially those of the vibrant italic – are very much in tune with a contemporary typographic sensibility.

PRINTED IN LAUSANNE, SWITZERLAND,

BY ENTREPRISE D'ARTS GRAPHIQUES JEAN GENOUD SA

ON TATAMI NATURAL PAPER, AN ACID-FREE SHEET